VOICES OF AMERICA

Italian Americans in World War II

DATE DUE

Italian Americans in World War II

Peter L. Belmonte

ARCADIA

Copyright © 2001 by Peter L. Belmonte
ISBN 0-7385-1907-3

Published by Arcadia Publishing,
an imprint of Tempus Publishing, Inc.
3047 N. Lincoln Ave., Suite 410
Chicago, IL 60657

Printed in Great Britain.

Library of Congress Catalog Card Number Applied For.

For all general information contact Arcadia Publishing at:
Telephone 843-853-2070
Fax 843-853-0044
E-Mail sales@arcadiapublishing.com

For customer service and orders:
Toll-Free 1-888-313-2665

Visit us on the internet at http://www.arcadiapublishing.com

CONTENTS

20.00 June 02

INTRODUCTION

This book is the natural product of my life-long passion for Italian-American history coupled with my deep interest in United States military history. In attempting to combine these two areas of interest, I initially studied Italian Americans in World War I. That was the first war in which a large number of Italian Americans served. Between 300,000 and 400,000 Italian Americans served in that war, yet there is practically nothing left which records their thoughts, concerns, or experiences. The student or casual reader cannot find first-hand accounts of what these men went through, and there are few, if any, surviving veterans. It is, for all practical purposes, too late to record first-hand accounts of Italian Americans in World War I.

Estimates vary, but between 500,000 and 1.5 million Italian Americans served in the United States military during World War II. Most of these men and women were of the second generation, the sons and daughters of immigrants, and presumably they were in a much better position to write and record their memories of their service. Therefore, the historiography of Italian Americans in World War II is in a much better state, although much needs to be done.

With so many having served, comparatively few Italian-American veterans of World War II have published their memoirs (see Appendix A for a partial listing of such works). Unit histories and other memoirs are replete with second-hand references to Italian-American servicemen, but there has been no concerted effort to directly preserve the memories of those veterans. I did not want to rehash already-published material. I intended to communicate directly with the veterans and to record unpublished material and memories of the men. Therefore, the information contained herein comes directly from the lips, pens, typewriters, and keyboards of the veterans themselves; in only three instances, this information was relayed through relatives of the men. The events recounted here happened almost 60 years ago, yet all the men recalled the major details and events readily. They were, for the most part, very young men during the war, and they all recognized that they were participating in something monumental and historic. The passage of time obscures details in men's memories; it becomes difficult to recollect precise names, dates, and places. None of the men interviewed exhibited confusion on matters of substance. Indeed, very few of them exhibited confusion over any facts they relayed to me. Most men readily admitted it when they couldn't recall something. By human nature, people may tend to embellish or to fill in details which memory fails to provide, yet there is nothing recorded here that I know to be false. Any errors contained herein are my own.

This book is not meant to be a history of World War II, nor is it meant to cover the strategies and battles of that war. I have included only enough background information to enable the reader to better understand some aspects of the veterans' service. Likewise, it is not meant to be a comprehensive history of Italian Americans in World War II. However, it is certainly more than a random collection of reminiscences. While there was not necessarily anything

scientific about the selection of interviewees, the men reflect a broad cross-section of experiences, and this can be considered an accurate survey of what the typical Italian-American serviceman experienced. The Army, Navy, Air Force (called the Army Air Corps and Army Air Forces during World War II), Marines, and Coast Guard are all represented. Interviewees include men who served on the front lines, in rear areas, and even well behind enemy lines, not to mention men who flew over the battlefields and men who sailed on the high seas.

I've recorded their words as they were relayed to me, verbally or in written form, and have made only minor changes in spelling and punctuation for clarity. I have also included occasional derogatory references to the Axis powers and soldiers, as the men used words that were commonly used at the time. The men felt no compunction about using these words, and I felt no need to omit them; these are words used by men in combat to describe their enemies, and they portray the flavor of the times. It is a part of the history of the war. This work is based upon numerous interviews (over the telephone, via e-mail, and via regular mail) with 50 veterans. In an effort to enhance readability, I have decided not to footnote each quote.

It is my hope that this book will bring honor to Italian-American veterans of World War II. These were ordinary men caught in extraordinary times, and their efforts and experiences deserve to be remembered. What follows, then, is their story.

ACKNOWLEDGMENTS

First and foremost, I'd like to thank all the veterans who participated in this project (their names are listed at the end of this book in the Sources section). They gave of their time and memories without hesitation, and they did so with good humor and patience. In the process of researching and writing this book, I have made many new friends among these men. I wish to thank the following individuals: Debbie (Serio) Albert, Rosanne (Azzari) Bennett, Jon Mangione, Ken Molinari, Pete Natale Jr., and Veronica (Sorrentino) Smith for facilitating contact with their respective fathers; Debbie Jolicoeur for providing information on her grandfather (Joe Jacovino); my cousin Diane (Belmonte) Patterson for providing photographs of her father (Dean Belmonte); Dr. Dominic Candeloro, fellow Arcadia author, for introducing me to Arcadia books; the American Italian Historical Association for advancing Italian-American studies; and the Italian American War Veterans for their untiring work on behalf of all United States veterans. Special thanks to editor Christina Cottini and the staff at Arcadia Publishing for their assistance.

I also wish to thank my wife, Pam, and our children: Heather, Michael, Laura, Anna, and Isaiah. Their love and encouragement sustained me throughout this project.

Chapter 1

PRE-WAR CIVILIAN LIFE

On the eve of America's entry into World War II, there were approximately six million Italian Americans in the United States. Most of them were immigrants who had come to the United States during the so-called Great Migration from 1880 to 1924, or the sons and daughters of those immigrants. Although they could be found in each state, they tended to congregate in the large metropolitan and industrial areas of the Northeast and Midwest, with another large contingent in California. The young men and women who would serve in the United States armed forces during World War II grew up in a variety of settings. Amiello T. Lauri, whose parents came to America from the Naples area at a young age, recalled his childhood:

I have one brother and one sister, all of us were delivered by a midwife in our cold water tenement house; the toilet was shared by two families. We were born and raised in Long Island City, New York. In those days, the neighborhood was divided into ethnic groups—ours being strictly Italian. All family relatives were within walking distance of each other, creating strong bonds, especially in time of need.

Louis A. Cerrone's family, also from the Naples area, "lived within a couple miles of each other on the south side of Chicago. It was primarily an Italian neighborhood with a few Irish Catholics." Attilio (Hal) Cenedella's grandfather came to the United States from northern Italy around 1900. He worked on the railroad and saved enough money to put his son, Hal's father, through college at M.I.T. Later, Cenedella's family started a road construction business, but "they lost everything during the Depression." For most Italian immigrant families of the era, hard work was a way of life. Edavide (Dave) Azzari's family, from Abruzzi, worked on farms in rural New Jersey during pre-war summers. "We lived in shacks with no heat, air conditioning, or water—we roughed it and improvised," he remembered. Sam Speranza, whose parents came from Avellino, agreed. "I had a very tough life. . . . the Depression years were hard," he said. Speranza felt that this experience helped prepare him for combat during the war. Stephen P. Budassi's father died in 1930, and Budassi had to leave school after ninth grade to support his mother and four siblings.

Al Miletta's father worked in the Calabrian sulfur mines before coming to the United States to work in the coal mines in Old Forge, Pennsylvania. Miletta's parents raised eight children on a meager coal miner's salary. "It was a struggle growing up under those conditions," he recalled. "I was born in 1920; then the Depression hit. They talk of poverty now [but] they never saw poverty like it was then. We wore homemade knickers and shirts, underwear and bed sheets made from 100-lb. flour bags. With eight kids, we used a lot of flour." Dean F. Belmonte's family also came from Calabria, his father working first as a railroad laborer, then as a gardener in Lake Forest, Illinois, where he raised six children.

Some Italian immigrants became shopkeepers or were skilled workers. Edward T. Imparato's parents had come to the United States from the Naples area. His father had been a cowboy out west in the 1890s, but had then settled down to open a

grocery business in Flushing, New York, where Ed was born in 1917. Michael V. Altamura's family lived in New York State, where his father was a civil service cabinetmaker on Governor's Island. Altamura's father "was a talented, old-world furniture designer and cabinetmaker from Italy." His skill soon caught the eye of General Hugh Drum, who asked the elder Altamura to design furniture for him. Mrs. Drum invited the young Altamura to play on the island army camp on weekends. Altamura remembered a "kind, gracious, aristocratic lady who served me lunch of small, square sandwiches, cookies, and milk." Although General Drum offered to sponsor the young man for West Point upon his high school graduation, Altamura ended up joining the Army and serving as an enlisted man during the war.

Thus it was with Italian-American families as the second generation approached adulthood. On the eve of World War II, the men worked at whatever jobs they could find. Some attended college, but as a rule, they were working to support themselves and their families as the nation emerged from economic depression and began to enter international strife. By 1940, with Europe engulfed in devastating war, the United States Congress passed a military draft bill, the Selective Training and Service Act of 1940. This Act provided for the registration and conscription of millions of American men in anticipation of America's involvement in the war.

ENTRY INTO THE ARMED FORCES

Some Italian Americans joined the regular Army, National Guard, or Army Reserve even before the draft began in 1940. Tony Ingrisano joined the Army Air Corps in 1929, at the age of 18. Ingrisano was stationed at Mitchell Field, Long Island, for a year. He remembered that some of the pilots would occasionally take him aloft in the dual seat open biplanes and allow him to take the stick for short periods. Ingrisano then joined the Army in 1935, and he was sent to China as part of the 15th Infantry. Discharged in the late 1930s, Ingrisano rejoined the Army Air Corps on December 31, 1941, shortly after the Japanese attack on Pearl Harbor.

Ed Imparato was a civilian instructor pilot in southern California in 1938. Even at that early date, he could see World War II on the horizon, and he decided to join the Army Reserve. As a pilot, he wanted to fly the faster, heavier aircraft available only in the Army Air Corps. So immediately after enlisting, he began a 13-lesson correspondence course that eventually led to his commissioning as an officer and his admission into flight school. He was called to active duty in November 1938 as a pilot with the rank of second lieutenant.

John W. Mangione, a refrigeration mechanic from Haverhill, Massachusetts, served briefly in an Army National Guard horse-drawn artillery unit in the late 1930s. Adelchi A. (Tony) Pilutti, who was born near Trieste, Italy, in 1921 and was brought to the United States as an infant, enlisted in the U.S. Army in January 1941. Pilutti, who lived in Steubenville, Ohio, at the time, was a farm worker; he knew he would be drafted before long and decided to enlist for a one-year stint

in the Army. Tony Cipriani, from Follansbee, West Virginia, enlisted in the Army on October 9, 1940. Cipriani recalled, "because the Army was expanding so fast, I moved up in grade from private, to private first class, corporal, sergeant, and staff sergeant. . . . When war broke out, I was already a staff sergeant." Stephen Budassi enlisted in the Army as a combat medic in 1940. After a series of promotions and transfers, he ended up as a platoon sergeant and eventually

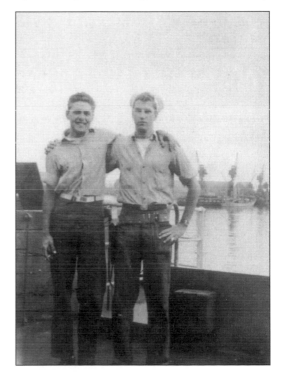

Mario Minervini is pictured at right, with a shipmate. They were members of the United States Navy Armed Guard. (Courtesy Mario Minervini.)

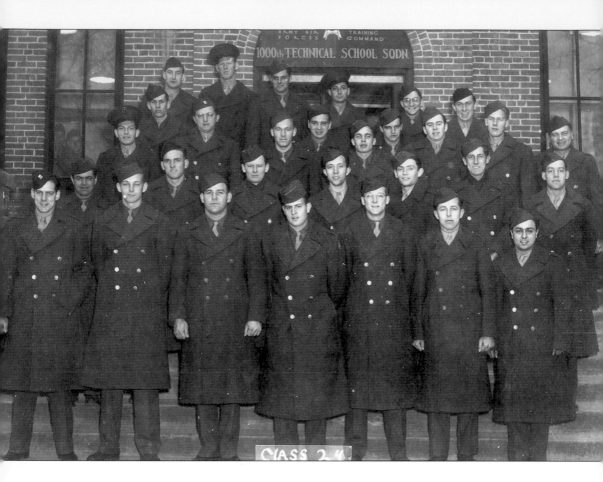

Lou Cerrone, front row, far right, and Radio School Class 24 are pictured at Truax Field in Wisconsin, c. 1943. (Courtesy Lou Cerrone.)

served in extensive combat in Europe as a United States Army Ranger.

Many men were quite young when they enlisted. Dom Manobianco enlisted in the Coast Guard at the age of 17, just as his father had done during World War I. Mario Minervini was also 17 when he joined the Navy. Vince Carnaggio dropped out of high school in Birmingham, Alabama, at the age of 16 to join the Navy in November 1942. He and a recruiter convinced his father to sign papers certifying that he was 17. While in boot camp at San Diego, "my drill instructor would yell at me every morning, 'Carnaggio! How old are you?' And I'd answer back, '17!' And he'd say, 'You're lying!'" As with other young men who lied about their age to enlist, patriotism drove Carnaggio to join the service. Albert J. Conti was so anxious to get into the Army that he tried to enlist at age 17, but his parents wouldn't sign a release for him. So, on his 18th birthday on February 24, 1944, he went to his draft board and asked to go early. His wishes were granted, and by May 1944, he was taking basic training at Camp Hood, Texas. Pete Palazzolo remembered an aviation cadet recruiting drive at his high school:

While a senior at Fenger High School in Chicago in 1943, some Navy Flight Training folks came to the school and offered a written exam to enter flight training. Shortly thereafter, the Army Air Corps came in with the same offer. I took both exams, but since no one ever heard back from the Navy, I and others decided on the Army. It was either enlist or be drafted in those times. I was 18 years old.

Being drafted or enlisting caused a great disruption in the lives of these ordinary men. Eighteen-year-old Amiello Lauri, drafted in April 1943, had never been away from home until then. By December of that year, he was on his way overseas. Ed Imparato's call to active duty in 1938 interrupted his fledgling university studies. Likewise, Lou Cerrone was drafted while he was in his second year in college in March 1943. Mario Minervini expected to "join the Navy and see the

Pictured here is Warren "Hardy" Sorrentino, 112th Infantry Regiment, 28th Infantry Division. (Courtesy Veronica Smith and Warren Sorrentino.)

world;" he was somewhat dismayed when, after training in the Navy armed guard, he was posted to Brooklyn Navy Yard, near his home. Warren Sorrentino was the youngest of eight brothers. By the time of his birth, his parents had run out of ideas for names and had decided to name him after then-President Warren Harding. Naturally, he soon received the nickname "Hardy." Sorrentino was an assistant golf-pro in New Haven, Connecticut, when he was drafted in 1943.

Jim Vitton should never have been drafted in the first place. He recalled, "I was age 23, married, with three sons, and a traffic dispatcher in a plant owned by Remington Rand that was making bomb fuses and artillery shells. Due to a record mix-up, my name was entered by our administrative office as no longer employed and in no further need of deferment." The predictable

happened, and Vitton was drafted. He contacted Remington Rand's Administrative Office, which in turn contacted Vitton's Draft Board. The Board refused to intervene, and Vitton reported for his physical. "I had been a desk jockey all my life and a serious asthmatic since age four. I doubted I would pass the physical," Vitton recalled. A colonel reviewing Vitton's chest X-rays questioned him about scar tissue on his bronchial tubes. After finding out about Vitton's asthma, the colonel requested more information from Vitton's family doctor. "The family doctor's office was two doors from my father's General Merchandise Store. We traded groceries for medicine as needed. When the letter from the Army came to the doctor, the secretary looked up my records in their files and found no asthma treatment in the past five years. She wrote a reply so indicating, placed it in front of the very busy doctor for his signature, and he signed it. I am certain he did not read it. As I recall, there was a subsequent apology to my father. So Uncle Sam got me anyhow."

Bill Donofrio, working as a clerk with a utility company in Flushing, New York, was originally classified III-A (deferred) by the Selective Service, because he and his sister were supporting their parents. Since most of his friends were being drafted, he asked the local draft board to change his status to I-A. They immediately did so, and he was drafted in early 1942. Gill Fox, whose maternal grandparents came from Naples, was a 26-year-old professional cartoonist living in Stamford, Connecticut, when he was drafted in 1944. Sent to Camp Van Dorn, Mississippi, for basic training, Fox brought along samples of his work in the hope that he would be assigned to a base or unit newspaper. As soon as he could, Fox sought out the 63rd Infantry Division newspaper and displayed his work. He was "hired" immediately and thus became an infantryman/cartoonist.

In 1942, Sam Mastrogiacomo was a marine machinist working on the battleship USS *New Jersey*, then being constructed at the Philadelphia Navy Yard. He kept pestering his mother, asking her permission to join the service. "My mother said, 'No, you've gotta work on the ship.' And I said, 'Ah, let the old guys do that.'" He saw an advertisement stating that the United States Army Air Forces (USAAF) were looking for skilled men, and he finally applied and entered the service on November 9, 1942, at the age of 19. Mastrogiacomo took basic training, then reported to machine shop school. Eventually, the pay disparity of his current status with his former civilian status dawned on him. As a civilian machinist, he had been making about $100 per week; now, as an enlisted man in the USAAF, he was making about $50 per month. While in training, he saw a bulletin board notice asking for volunteers for aerial gunnery school. Applicants had to have good eyes, weigh less than 170 pounds, and be under 5' 10" in height. Without informing his mother, Mastrogiacomo applied for aerial gunnery school.

Sam Mastrogiacomo's two twin brothers, Tony and Pete, enlisted in the military in 1943. At the recruiting station, the two men were separated, Pete being placed into the Army, and Tony directed toward the Navy. Since the brothers wanted to remain together, Tony, who wanted to be in the infantry, pled with the recruiting officer, and he was allowed to join his brother in the Army.

Hal Cenedella was a 21-year-old college student at the University of California when he tried to enlist in the Marines at Alameda, California, in 1942. Due to a childhood accident that left him with one flat foot, the Marines turned him down. Cenedella waited a few weeks then went back to the recruiting station. This time, a different Navy doctor examined him, and he was approved to join the Navy. After graduation from college in early 1943, Cenedella attended the Navy commissioning course at Columbia University. He graduated and was commissioned an ensign in the Navy in 1943.

TRAINING AND STATESIDE DUTY

Upon entry into the military, the former civilians were thrust into an alien world. They learned new words, learned how to march and salute, were issued ill-fitting uniforms, and received a drastic haircut. And they were introduced to the mystifying ways of military bureaucracy. After their induction, men were sent to various training bases. Their destination and type and length of training depended upon their classification. Their classification depended largely upon their scores on the Army General Classification Test, or AGCT. The rapidly expanding armed forces severely taxed military housing and training facilities, and the military sent some men to civilian contract schools. Men were trained and housed in hotels in Chicago, New York, Miami, etc. Specialized and officer training programs also expanded to civilian colleges and universities across the country.

Some men were encouraged to apply for Officer Candidate School (OCS). Tony Cipriani, who was quickly promoted to staff sergeant in the rapidly expanding Army, applied twice for OCS. Accepted on his second try, Cipriani attended OCS at the Infantry School at Fort Benning, Georgia, from March through June 1942. Upon graduation, he was commissioned a second lieutenant. Officers urged Mike Altamura to apply to OCS while he was in training at Fort Knox, Kentucky. He was considering doing so, until one day he saw officer trainees outside in the freezing cold doing calisthenics clad only in their underwear. Altamura then changed his mind about OCS. In 1942, Tony Ingrisano, who had originally enlisted in the Air Corps in 1929, and had re-enlisted in late 1941, was serving as a USAAF Link Trainer instructor. An officer supervisor of his ordered him to meet the OCS board, which he was very reluctant to do. Because of his defiance, he "struck the board as a man of poise and good officer material." As a result, he attended OCS and was commissioned a second lieutenant in January 1943. Some men volunteered for

William Kramer, left, and Mike Altamura, are pictured at the Louisville YMCA on November 1, 1942. Kramer sometimes sang on a radio show from Fort Knox: "He's got a swell voice." (Courtesy Mike Altamura.)

Sam Mastrogiacomo shows off his new aerial gunner's wings. (Courtesy Sam Mastrogiacomo.)

special assignments such as airborne infantry or parachute training.

Johnny Campisi enlisted in the Army in February 1942. After basic training, two sergeants visited the soldiers and solicited volunteers for parachute training. Campisi recalled, "I volunteered. I didn't think I'd pass the training, I just joined because you got a half a day off." Campisi did pass the training and was assigned to the 503rd Parachute Infantry Battalion. He received training at Fort Benning, Georgia, and Fort Bragg, North Carolina, before attending desert training at Needles, California. Following desert training, and a month back at Fort Bragg, he departed for the Pacific, wondering if he'd have opportunity to apply the desert training there. Tony Pilutti, another airborne volunteer, received his jump wings at graduation in December 1943, much to the dismay of his parents who were mortified at the thought of their son jumping

out of an airplane.

The airborne units considered themselves to be elite units, with special training and skills. They were awarded jump wings and were allowed to wear jump boots with their trousers bloused in the top of the boots. Once, when Tony Pilutti and a fellow paratrooper were visiting Washington, D.C., an MP stopped them and told them to un-blouse their trousers lest they be considered out of uniform. "This *is* my uniform," Pilutti replied. The MP insisted, and Pilutti's friend told the MP, "Why don't you reach down and un-blouse them yourself?" Not amused, the MPs apprehended Pilutti and his friend and sent them on a train, under guard, back to their base. The MPs' report followed the men, and they were called into their company commander's office. "Did you kill the SOB MP?" asked the captain. Pilutti replied in the negative; "Well, you should have," retorted the captain.

Sam Mastrogiacomo attended aerial gunnery school at Laredo, Texas. He had never flown in an airplane before, but now he had to fly in an AT-6 Texan trainer aircraft with "a .30-caliber machine gun on the rear cockpit, and mounted on a swivel track. We were to shoot at a sleeve target towed by another AT-6. To qualify, you had to hit the target with at least 30 percent of the ammo. I did pretty good, finishing in the top three of the class." Upon graduation, Mastrogiacomo was awarded silver air gunner's wings and sergeant stripes. He sent the wings home to his mother, whom he had yet to tell about his volunteering for air gunnery school and who was greatly concerned about his safety. Mastrogiacomo recalled that his mother said, "You're a sneak! You've always been a sneak." Mastrogiacomo also recalled that the NCOs struggled with his long Italian name. "If we fell out for a roll call, and I'd see the sergeant begin to scratch his head and squint at the roster, I'd just shout 'Here!'"

Art Pivirotto also entered aerial gunnery school after Navy boot camp. Following training at various bases, he trained at the

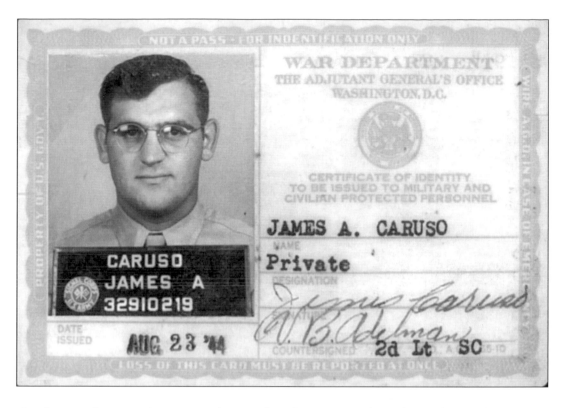

WAR DEPARTMENT
THE ADJUTANT GENERAL'S OFFICE
WASHINGTON, D.C.

CERTIFICATE OF IDENTITY
TO BE ISSUED TO MILITARY AND
CIVILIAN PROTECTED PERSONNEL

JAMES A. CARUSO
NAME
Private
DESIGNATION

CARUSO
JAMES A
32910219

DATE ISSUED
AUG 23 '44

2d Lt SC

Combat medic Jim Caruso's military identification card is shown here. The reverse specifically identifies Caruso as a medic "engaged exclusively in the removal, transportation, and treatment of the wounded and sick . . ." (Courtesy Jim Caruso.)

Navy's Gulf Beach, Florida, gunnery school. One of the weapons with which the men trained was the shotgun. The men shot skeet in an effort to learn the aerial gunnery principle of leading the target. Pivirotto described a course that consisted of a gasoline-powered vehicle driven on rails. In the back of this vehicle rode the trainees, seated on a swivel-seat, armed with a shotgun. As the vehicle proceeded down the tracks, a series of 16 traps would, in sequence, launch clay targets. The men swiveled and fired at the targets. "You couldn't get out until you broke 'em all," recalled Pivirotto.

Jim Caruso described his training as a combat medic: "I think that you could classify it as a step above first aid. We had to give intravenous shots to install blood plasma, bandage the wounds, inject pain medicine, prevent shock the best we could,

Tony Lima, United States Marine Corps, is shown here right after boot camp. (Courtesy Tony Lima.)

and keep them as comfortable as possible until they were transported back to better medical care. The type of wound dictated the type of treatment. There were other more advanced instructions which the combat aid man could not possibly use in front line combat."

Tony Lima entered the Marine Corps in September 1943, and went through boot camp at Parris Island, South Carolina. He recalled: " . . . I will tell you that in my opinion training was very tough, and I will also tell you that I was glad when we graduated and were called Marines for the first time." After graduation, Lima was given two weeks furlough; he wouldn't see home again until his discharge in May 1946. Lima attended an eight-week water purification course at the engineering school at Camp Lejeune, North Carolina, in November 1943. In May 1944, he was assigned to Company B, Fifth Pioneer Battalion, Fleet Marine Force, Fifth Marine Division. "That is when the heavy training really began," he recalled. "We were trained in the use of various weapons besides the rifle and carbine . . . hand grenades, bazookas, .30 and .50 caliber machine guns, the BAR (Browning Automatic Rifle), and various types of explosives." As an omen of things to come, Lima also practiced beach landings.

Jim Vitton, drafted despite his asthma, attended infantry basic training at Camp Wolters, Texas. Since he was qualified to apply for OCS, he sent his request, along with accompanying documentation, to Fort Ord, California. Soon his papers were returned with, "Quota filled, please re-apply at your next opportunity." There were no more opportunities. While he awaited his first asthma attack so he could go home, he was told that he was to attend radio school, which he felt was better than regular infantry training. The camp instructors planned to put him and his fellow trainees through the full infantry training, normally about 16 weeks long, in just eight weeks, and then devote the next eight weeks to radio school. At the end of the first eight weeks, they were told that, "due to limited casualties in Infantry Radio personnel there was no current need for same, so we would complete basic with the regular infantry people. So much for Radio School." Still, Vitton recalled that the training did "build me up physically and I did learn about soldiering." The training served the men well. "We did the whole bit: weapons care, weapons qualification (pistol, M1, carbine, bayonet, grenade, 60 and 81 mm. mortar, .30 cal. light and water-cooled machine gun), guard duty, infiltration course, river crossings, night exercises, three 12-mile hikes per week, a 30-mile graduation hike, etc. We even had the pleasure of being in a foxhole and having a tank run over us."

Vitton described his graduation hike:

Our graduation hike was to be 30 miles with full field pack. In addition to the 30 miles, the hike began by crossing two extremely high hills. They had been named Separation Hill and Elimination Hill. Separation Hill was said to separate the men from the boys, and Elimination Hill was said to eliminate the men. After managing the two hills, we set off into the balance of the 30 miles. We had left at dusk. I was in the last Company of the last Regiment on the hike. Also, since my surname began with a "V," I was next to last in that long, long line of men. During the night, there were a lot of dropouts for heat, exhaustion, blisters, etc. They would enter the "meat wagons" that followed us. Somewhere around a half of the way through the hike, I began to get my asthmatic wheeze. As I continued, it got a little worse. I began to think that here was where Uncle Sam and I parted company, but I waited to report my condition until I had a full-fledged attack. By the three-quarter mark, it was getting pretty bad. I walked a little further, and it was no worse. A little further and it was less bad; a little further, less bad, and by the time the hike was over, early in the a.m., it was gone. And I have never had it since.

Twin brothers Tony and Pete

C.J. Lancellotti is pictured at left with a friend, about 1953. (Courtesy C.J. Lancellotti.)

Mastrogiacomo, upon completion of basic training, were sent directly to the Aleutian Islands, Alaska, to undergo specialized infantry training as part of the 138th Infantry Regiment. The men spent 13 months there in intensive training. "We got in real good shape," Tony recalled. "We ran 9 miles in one hour and 46 minutes, with full field pack." Perhaps equally as important as the physical conditioning the brothers underwent was their exposure to combat veterans of the Aleutian campaign. "Some of those men were 28 or 29 years old; they used to call us 'Junior,'" he recalled. The younger men learned a lot from the Alaskan veterans, most importantly to keep calm under fire and not to panic.

Carmine J. (C.J.) Lancellotti recalled his initial experience reporting for training at Camp Upton, New York, in November 1942:

The place was overflowing with men

Al Panebianco is pictured here. (Courtesy Al Panebianco.)

being given orders, being assigned to tents, lining up on chow lines, and finally taking tests of various kinds late into the night. Medical shots were also given. It was hectic but fun, because a lot of the men I had been drafted with were friends with whom I had grown up on the streets of Corona and Jackson Heights, New York.

Lancellotti was processed and sent to Miami Beach, Florida, for basic training. There, the men "were assigned to hotels along the ocean. We thought we were in heaven." Lancellotti enjoyed his training experience. He recalled: "We were issued summer uniforms, learned some close order drill on the streets, marched while singing 'off we go into the wild blue yonder' (believe it or not we received song sheets with Army-type songs), got more shots, visited the dentist, had teeth pulled, and generally enjoyed being in Florida and away with some friends."

Following this training, Lancellotti received orders to the Signal School at Camp Crowder, Missouri. There, Lancellotti learned the Morse code and learned to operate teletype machines and to visually read the tapes. He recalled: "In addition to attending school, we received military training, close order drill, weapons training, rifle range firing, field radio instruction, scrubbing floors, inspections, KP, guard duty, and other associated military necessary duties." Upon graduation, Lancellotti received a certificate as a High Speed Radio Operator (25 words per minute) and a promotion to corporal.

Al Miletta, classified as an aircraft armorer, received only three weeks of basic military training, consisting mostly of marching, at Dale Mabry Air Field, Florida. He then received specialized training in the maintenance of aircraft weapons systems. This training covered the .30 and .50 caliber machine guns and 37 mm. cannons common on the airplanes at the time. Miletta and his fellow armorers had to learn how to pull the machine guns out of the airplane's wings, clean and repair them, and replace them in

working order. Working on the Bell Aircobra P-39, he recalled that "there were three propellers, and the .50 caliber guns had to be synchronized to fire between the propellers; if not, a disaster was forthcoming." Following this, he received more intensive training at Muroc Field, California.

Paul DeCicco enlisted in the Army from college in July 1943. He was sent to basic training with the Corps of Engineers at Fort Belvoir, Virginia. DeCicco recalled that the training "was quite comprehensive. Since we were combat engineers, we had the full infantry combat course, small arms, bazooka, flame thrower, etc. We also [had training in] bridge building (Pontoon, Bailey, etc.) demolitions, mine laying, and clearing" Vince Consiglio, also in the combat engineers, remembered the same type of training. "We laid mines, picked up mines, and built bridges," all skills he'd eventually employ in combat. Following training at Camp Swift, Texas, Consiglio's unit moved to its port of embarkation in Virginia. In an effort to preserve secrecy, the men moved by truck to the "middle of a desert," then boarded a train that took "a left turn" and followed a mystifying route to Virginia by way of Canada and Niagara Falls, New York.

Classified as a clerk-typist, Al Panebianco attended basic training with the 6th Training Battalion at Camp Wheeler, Georgia. At that time, the basic course was shortened from 17 weeks to 13 weeks. There, Panebianco's training "consisted of four weeks of basic, which included close order drill, firing a weapon, hiking, learning General Orders, etc. The remaining nine weeks was spent in Clerks and Stenographers School. We were trained to fill any clerical position, whether it was at the company or division level." Panebianco "attended classes to learn how to type letters according to Army regulations. In one classroom there were approximately 40 typewriters for us to practice and become better typists. After completing the course, we were given an MOS [Military Occupation Specialty code] 405, which is clerk typist."

Following this training, Panebianco was sent to the Camp Kilmer, New Jersey, Port of Embarkation, for shipment overseas. Officials there needed clerical help in their offices, so they pulled Panebianco out of his group and put him to work as a clerk at the port. At that time, men could stay a maximum of three months at any Port of Embarkation, and then they were moved overseas, unless they were a part of the port cadre. After three months at Camp Kilmer, Panebianco "was sent to Camp Shenango [Pennsylvania], another port of embarkation. I could never understand this move. However, I was pulled again to help out with clerical work." Panebianco recalled that "most of the work at the ports of embarkation involved typing various forms for the movement of troops. It was interesting work, and I enjoyed it—especially being exempt from the normal military chores." Three months later, he was on a troop ship headed for Casablanca.

John Mangione was drafted in March 1942, and sent to Fort Bragg, North Carolina, for artillery basic training, which he described as "monotonous routine." Drafted in September 1942, Mike Altamura did very well on his AGCT, and he was sent to tank maintenance school. Altamura recalled, "I had no previous experience, but I did own a Model A." He attended Tank Maintenance School at Fort Knox, Kentucky, for three months. "We learned fast," Altamura said of his rapid training. Following this training, Altamura and his unit stayed at Fort Knox, testing a new tank, the M4A3, for six months. "We drove these things 24 hours a day to see what they could take," he recalled. It was dangerous duty; men pulled long hours in shifts, six and seven days a week, and some men were injured or killed in accidents. Altamura remembered that for lunch every day they were given "the same damned sandwiches—peanut butter and jelly, and water." After this six-month test period, Army inspectors evaluated Altamura's unit and were dismayed to find that they didn't score well on their tank gunnery trials. "How could we? We hadn't fired our guns for six months,"

"How to meet girls with cars, Columbia, SC, 1943." Mike Altamura clowns for the camera. (Courtesy Mike Altamura.)

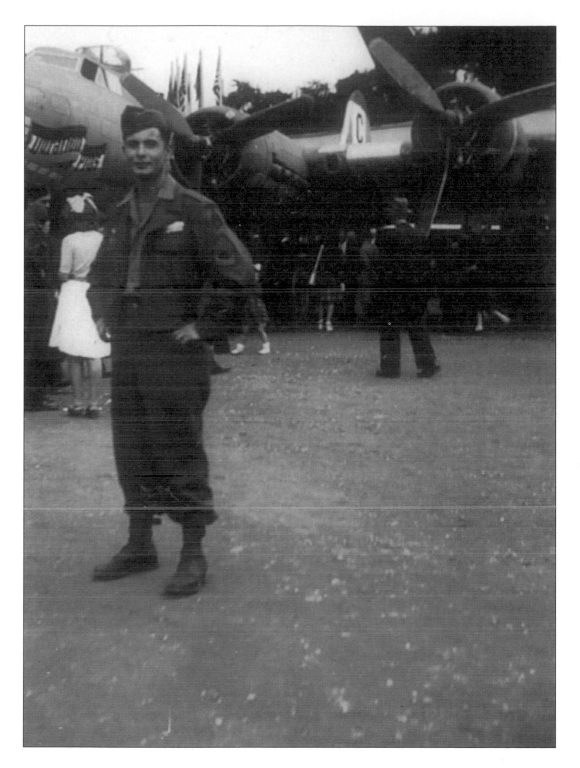

Sam Speranza, 254th Infantry Regiment, 63rd Infantry Division, poses in front of a B-17 bomber during a special display under the Eiffel Tower, Paris, 1945. (Courtesy Sam Speranza.)

he recalled. So the entire battalion was sent to Tennessee for training and maneuvers.

But training wasn't always dreary, dangerous, or monotonous. Dave Azzari went through mechanized infantry training at Camp Chaffee, Arkansas, in 1943. "I loved it," he recalled. "We'd really race around in those half-tracks." And Jim Vitton, undergoing infantry training, met up with a soldier who was an entomologist by trade. This man would bring a long-handled butterfly net with him to the field, and sometimes Vitton would help him catch bug specimens to send back to his university. "The other guys in the training unit got a laugh about those two nuts with the butterfly net," he remembered. Men also had to get used to a different dining experience. Armand Castelli recalled that "the food was strictly American, and at first it was hard to adapt to it, but after a week I adjusted to it, especially after being used to Italian food."

The exigencies and pressures of war often produced anomalies in training and classification. Men were sometimes hurried through training in an effort to bolster manning at units overseas or to produce cadres to train follow-on recruits. Albino Santelli was drafted on July 3, 1942, and trained at Camp San Luis Obispo, California. Six weeks later, he was sent to the South Pacific. Dom Constantino enlisted in the Navy on June 7, 1942, at the age of 18. After only five weeks of boot camp at the Naval Training Station at Newport, Rhode Island, Constantino was ordered to Solomons, Maryland, for amphibious training. There, he became a coxswain and learned to operate the famed Higgins boats, amphibious landing craft, 36' and 50' boats that carried personnel and vehicles from larger ships to the beach during assault landings. Constantino recalled, "I was 18 years old and gung-ho; I wanted to run those boats right up on the beach!" After five months of training in Chesapeake Bay, he became an instructor himself, training others as part of the school cadre. Constantino felt his training was very rushed. He stated, "I hardly

knew how to run the boats myself, and now I was training others." Sam Speranza was drafted in January 1944. After his basic training, he became a drill instructor (DI) in charge of training new recruits. He had no real training for this important job and was "mostly self-taught from basic training."

Sam Mastrogiacomo's class in aerial gunnery school was rushed through in nine weeks instead of the normal six months. At his follow-on training in armament school at Lowry Field, Colorado, the men attended classes day and night, six days a week, allowing the course to be completed in three months instead of the usual six months.

Frank Carnaggio completed basic training at Miami Beach, Florida, in early 1943. His AGCT indicated he had mechanical aptitude, so he was sent to engine overhaul school at the National School of Aeronautics in Kansas City, Missouri. He recalled, "After I got out of engine overhaul school, I never saw the inside of an engine again." Carnaggio ended up in an Air Forces Service Group responsible for salvaging and repairing crashed airplanes. Mike Ingrisano, brother of Tony Ingrisano who was mentioned above, joined the Army Air Corps in September 1942. Following basic training at Miami Beach, Florida, he attended radio operator and mechanic school at the Stevens Hotel in Chicago; and then he attended a civilian training school in Kansas City—the TWA Advanced Training School.

Pete Palazzolo, who enlisted in the Army Air Forces at the age of 18 while in high school, also attended basic training at Miami Beach. "The government had leased most of the hotels there and converted them to troop housing," he remembered. "The golf courses were converted to drill fields and obstacle courses. The movie theatres were converted to training centers, etc." Palazzolo described how his training routine was tinged with sobering realism:

We took PT [physical training] on the beaches, and several times we witnessed Navy destroyers engaging U-Boats in the distance. During that period, the Germans

This is Bill Donofrio, 8th Armored Division, 1942. (Courtesy Bill Donofrio.)

were sinking shipping off our coastlines with regularity. In fact, all the hotel windows were painted black and covered with blackout curtains to eliminate background light at night.

And if that weren't enough, Palazzolo recalled that "my drill instructor was an old buck sergeant from pre-war days—mean and crusty. There was always the threat of the 'infantry' as an incentive to do well."

The intricacies of the military supply system were another matter of concern to the newly inducted trainees. Jim Vitton recalled how he was issued clothing:

When I went for my uniforms and gear with a group of 100 or so trainees, we were lined up and passed through the supply sergeant's building. At each station we were asked as to size and were given an article that supposedly corresponded size-wise. When I got to the combat boot area I was asked my shoe size. I told them nine. I was given a 10. I said, "I only wear a nine. These are too big." I was told, "You're in the infantry now; you'll grow into them." You know, I never did. And later I was able to get a proper fit.

Amiello Lauri completed basic training at Atlantic City, New Jersey, and was assigned to the 555th Signal Air Warning Battalion at Drew Field, Florida. At the time, the unit was involved in highly secret radar operations. However, "in an effort to assemble outfits as fast as possible and get them overseas, classifications didn't count, and I was sadly listed as an MOS 521—General Duty Soldier. I didn't receive any formal training, although I did have electronic training as a civilian, but I was told the T.O. [Table of Organization] required X numbers of 521s, and there was nothing that could be done." Lauri left for England in November 1943, as a general duty soldier.

Armand Castelli attended infantry basic training in the stifling heat of Camp Blanding, Florida, during the summer of 1945. He remembered the grueling routine: "By the fifth week we began the long marches, at first a 3-mile, then a 10-mile, and

finally a 15-mile march, with full field pack, 9-pound M1 rifle, and no water." In addition, the men had to do two 15-mile speed marches. "All of them were done in record time, and I did not fall out." Their training ended with a 20-mile march with a 40-pound field pack and the M1 rifle. Such training was designed to toughen the men. Castelli recalled that his infantry training "was hard [and we] were told that when we were finished we would be in the best physical condition of our lives, and they were right." Pete Buongiorno commented upon his infantry training. The men were required to know their M1 rifle intimately. "You learned how to take it apart and assemble it back together, and then they tell you that before you are done with basic you will do it blindfolded. I said yeah, right—well you do it so often that you can do it blindfolded," he recalled.

Men were shunted through the system in bewildering fashion. Bill Donofrio attended basic training with the newly formed 8th Armored Division at Fort Knox, Kentucky, in 1942. Due to vacancies in the unit, Donofrio was quickly promoted to staff sergeant; in January 1943, the unit moved to Fort Campbell, Kentucky. By now a tank platoon sergeant, Donofrio continued training with the unit. However, "training was interrupted two months later when we were changed to the 20th Armored Division. I never understood it, but from our ranks, a cadre was formed to reactivate the 8th Armored Division in Camp Polk in Louisiana."

Donofrio recalled:

About that time, the 1st Armored Division was suffering heavy losses in Africa. In a matter of days, all our privates were to be shipped out as replacements [for the 1st Armored Division]. In preparation, we spent three days in the field with those privates teaching them to fire the 37 mm. cannon in our tanks. Looking back, it was ludicrous; each GI got to fire three rounds, not at real targets, but at trees several hundred yards away. I did tell my tank commanders to allow extra rounds to the

Aviation Cadet Peter C. Palazzolo (age 19) is pictured in San Antonio, Texas, c. 1944. (Courtesy Pete Palazzolo.)

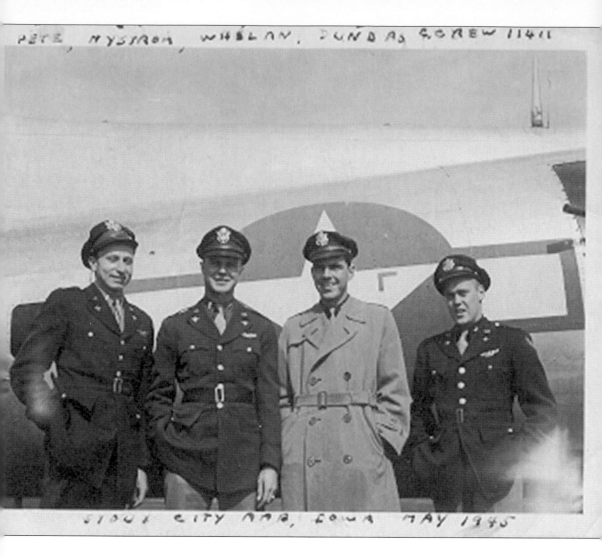

This B-17 crew is pictured at Sioux City, Iowa, April 1945. Left to right are: Lt. Palazzolo—Navigator; Lt. Nystrum—co-pilot; Lt. Whealan—Aircraft Commander; and Lt. Dundas—Bombardier. (Courtesy Pete Palazzolo.)

more inept. Not that it did much good; I always wondered what ever happened to those guys.

Donofrio's training saga was far from over. He was soon sent to Camp Chaffee, Arkansas, as part of the cadre for another newly forming division, the 16th Armored Division. Conditions at Chaffee were Spartan and rough. Donofrio recalled, "Chaffee was the pits; tarpaper shacks as barracks and miserably hot. It was so stifling, we slept outside with our mattresses on the ground." Donofrio, who had been urged earlier to apply to Officer Candidate School, found the wait for personnel to fill the ranks of the division to be interminable. When he found out that he wouldn't be a platoon sergeant in the new unit, he decided to take a test for Army Air Forces training. He passed the test for aircrew training to become a pilot, navigator, or bombardier, and he reported to Sheppard Field, Texas, for more screening. Finally, he was admitted to the training program at Oklahoma A&M College.

Donofrio recalled, "It was great, going to college and flying Piper Cubs. There was a lot of Mickey Mouse discipline, but I didn't mind. ('Hit a brace! Suck in your gut! That will be two punishment tours Mister!') The many coeds and Navy Waves attending school there did make things more pleasant. Sorry to say, it didn't last." After five months, the Army Air Forces revised their manpower projections, and most of the students, including Donofrio, were released. Donofrio reflected, "It may have been for the best. I found I really wasn't all that crazy about flying; besides, my flight instructor once said I flew like an old lady."

Instead of being sent to an armored unit, Donofrio was sent to a Quartermaster unit at Fort Warren, Wyoming. There, "we were thrown in with mostly GIs awaiting discharge for convenience of the government. . . . They weren't screw-ups, they just couldn't adjust to the Army. Some were probably mentally retarded." Donofrio further described his stay at Fort Warren:

There was no training, though I was a barracks chief. I really didn't report to anyone, so I was on my own. I passed the time playing basketball at the post gym, while a good Air Corps buddy kept the troops busy marching or scrubbing barracks. The only good thing about Warren was that nearby Cheyenne was a great place for fun and games. Being unassigned made us aware we could end up in a laundry, transportation, or even graves registration unit; a very sobering thought. So, three of us did the unthinkable, we volunteered. Not only that, we volunteered for the infantry. We could have tried for the paratroops, but we couldn't see jumping out of airplanes on purpose. The Army quickly accepted our offer and shipped us to Fort Leonard Wood in Missouri.

At Fort Leonard Wood, Donofrio was assigned to E Company, 274th Infantry Regiment, 70th Infantry Division. Although having had no infantry training, he was made squad leader. After the hiatus at Fort Warren, Donofrio found the infantry refreshing. "I found in the infantry a sense of purpose I'd not seen before. We trained very hard, and I liked it, even knowing where we would end up. In about four months, we were alerted that we were shipping overseas, but not told where." Donofrio's unit departed before they finished their scheduled training.

The training for officer aircrew members was lengthy and required numerous moves. Vincent Guzzardi, a fighter pilot, related his training journeys.

I took the test for Army Air Corps Cadet my senior year in high school. Accepted into the Cadet program January 1943, and shipped out from Newark to Atlantic City, New Jersey, for basic training. Then to Burlington, Vermont, for five months of college courses at the university. Then to Nashville, Tennessee, for more tests and exams to determine whether I was fit for fighter or bomber pilot or bombardier, navigator, etc. I qualified for fighter pilot. Sent to Maxwell Field, Alabama, for cadet training taking two months of ground school. Then to Arcadia, Florida, for training in the P-17 Stearman. After 90 hours of flight training, was sent to

Lou Cerrone, 404th Fighter Group, is shown second from left. "Doug White, me, Red Wilson, Watters, and Scott." (Courtesy Lou Cerrone.)

Bainbridge, Georgia, for flight training in the BT-13 single engine "lead sled." After 90 hours there, was sent Marianna, Florida, for flight training in the AT-6 (beautiful plane), graduated and got my wings and commission there. Then to Eglin Field, Florida, for training in the P-40 (the famous Flying Tiger plane). Then to Bradley Field, Connecticut, for flight training in the P-47 Thunderbolt (best damn plane ever built). Finally, shipped out from Monmouth, New Jersey, in November 1944 to Liverpool, England, on a Victory Ship.

Thus it took almost two whole years for Guzzardi to go from high school student to qualified fighter pilot in Europe.

Pete Palazzolo, also an aviation cadet, recalled that after basic training, he was sent to Kent State University in Ohio for "a five-month crash course in physics and math." Following this university schooling, Palazzolo ran into one of the frustrations that beset military training during the war a clogged training "pipeline."

I was put in a "holding" status. I was sent to Independence AAF [Army Air Field], Kansas. That was an intermediate pilot training base, and we were put to work refueling and otherwise looking after training aircraft, BT-13s and BT-14s. Most of the time we just sat in the cockpit and played with the radios.

Next Palazzolo was sent to San Antonio Aviation Cadet Center.

There we were tested and re-tested for aptitude, coordination, etc. I was asked what I would do if I were on a bombing mission over Italy. Italy was an enemy, and I was an Italian. My answer was and of course had to be—I would do the mission!! Following testing we were officially elevated to aviation cadet status, and our pay was raised to $75/month from the original $30/month.

At long last, Palazzolo attended navigator training at Hondo AAF, Texas.

Navigator training was about 16 weeks long. Ground school courses included weather, maps, E6B computer, star identification, Morse code, DR [dead reckoning] plotting, sextant use, etc. We trained with A-10 sextants. . . . We did our flight training in Beechcraft AT-7s.

Palazzolo graduated as a flight officer at the age of 19 in January 1945. After graduation, he volunteered for B-29 crew training at Sioux City, Iowa. "When I arrived, there were no B-29s to be seen—only B-17s," he remembered. "There was no career counseling as we have now—in fact to be blunt, no one seemed to know much that was going on." So Palazzolo attended B-17 combat crew training instead. "About the time we completed our crew training, Germany surrendered," recalled Palazzolo. "Our crew was disbanded, and I was assigned to Selman AAF in Monroe, Louisiana. Months later I left active duty and entered reserve status."

Sometimes a man's civilian experience and training came into play in unusual ways. Salvatore (Tootie) DeBenedetto recalled:

I went to Camp Croft, South Carolina, for my basic training. We had just gotten there standing in line with our bags, along came a car with a one-star general; just as it passed me, the car died. The sergeant went over to the car, next thing I heard was, does anyone know anything about a car, I raised my hand, went to the car, raised the hood, I checked the points . . . I got the car started. The general asked me for my name; I told him [and] I started driving for him a short time later.

Because of this experience, DeBenedetto later became a driver for Major General Herman F. Kramer, commander of the 66th Infantry Division.

Tony Pilutti, who enlisted before Pearl Harbor, prepared to go overseas with the 37th Infantry Division in May 1942. At the San Francisco Port of Embarkation, officials checked all the men's records while their bags were loaded on the transport. Pilutti was preparing to board when he was ordered to report to regimental headquarters, along with five or six other Italian-American and German-American soldiers. At headquarters he was told that having been born in Italy and brought to the

United States as an infant he wasn't an American citizen and was, in fact, an enemy alien. The Army therefore had to investigate his status more thoroughly. He was unceremoniously placed on a ferryboat and sent to Angel Island detention center. "We made a stop at Alcatraz to drop off mail," Pilutti recalled.

Pilutti, along with other detainees, stayed on Angel Island for two months while the government investigated his history. While there, he mainly pulled KP. "There just wasn't much going on," he recalled. Periodically, as their cases were resolved, some men left while others were newly admitted. Finally, in June 1942, Pilutti was released. His old unit already shipped to the Pacific, Pilutti was sent to Camp Haan in southern California as a member of a Quartermaster unit. "They tried to make a cook out of me, but it didn't pan out," he quipped. In July 1943, he was sent to Fort Hood, Texas, where he became part of the cadre engaged in giving basic training to recruits, most of whom were ex-college students bound for Officer Candidate School. This didn't suit Pilutti, who said, "training people got to be old stuff, and I became antsy." Finally, in November 1943, he applied for parachute school and earned his jump wings the next month.

As noted above, after training, some men served stateside as cadre for units engaged in training recruits. Others received orders assigning them to stateside non-training duty. After graduation from Signal School, C.J. Lancellotti received his assignment. "Imagine my elation when I found that I, along with several other men, had been assigned to the 137th Signal Radio Intelligence Company (Aviation) stationed at Mitchell Field, Long Island, New York, not too far from my home," he recalled. The radio intercept section was located at the Jones Beach Hotel in Wantaugh, Long Island. According to Lancellotti, the unit's mission:

. . . *was intercepting German radio transmissions and attempting to locate the source of the transmission. Mostly we searched for transmissions from submarines, which mostly came during the times when the subs would come to the surface to charge their batteries. German call signs all began with a "D," so we scanned the airwaves listening for weak sounding radio messages, waiting to identify them as German. This information was copied and the radio frequency sometimes sent to the direction finders along the coast to try to get a fix on the sender. We also copied messages from submarine headquarters to the submarines. High-speed radio traffic was copied onto plastic records on an old type stenographer recording machine, and later transcribed at a slower speed.*

Lancellotti served on Long Island for a year until his unit was ordered overseas in April 1944.

Chapter 4

OVERSEAS

The Trip Over

Army ground troops destined for assignment overseas usually traveled by troopship. This was almost always a somewhat miserable trip, with long periods of monotony, uncertainty, seasickness, and discomfort. Albert Miletta, an aircraft armorer in the Army Air Forces, rode on the *Anne Arundel*, a converted banana boat. Departing in October 1942, it took 21 days for the vessel to arrive in North Africa from Newport News, Virginia. In December 1943, Amiello Lauri departed the United States on a captured, converted World War I-era ocean liner, overloaded with 2,000 troops. The English crew "fed us twice a day with food we immediately heaved, that is if we were desperate enough to eat it," recalled Lauri. He spent his 19th birthday aboard ship, "sick as a dog, along with most of the troops."

Frank Carnaggio left the United States in November 1943, bound for England during an icy North Atlantic crossing. "The boat pitched violently, and everyone was seasick. Even some of the sailors were turning green. It was an unhappy time in my life," he recalled. C.J. Lancellotti recalled his experiences aboard the *Arundel Castle* during an April 1944, Atlantic Ocean crossing:

We were assigned the usual fold-down bunks, four deep, down in the hold of the ship. The ship was packed with troops, so we slept in three shifts. That bunk was ours for eight hours of the day. The rest of the day or night was spent above decks; [except in] inclement weather. . . . The ship was not very clean and the food was terrible. Many
of the men became ill (seasick), which made it unpleasant in the sleeping areas. The lowest bunk was not the best place to be. The day was comprised of exercising, playing cards, playing dice, looking at the ocean, and laying around. We had periodic lifeboat drills.

Most troopships crossed the ocean as part of a large convoy. Others, such as Lauri's vessel, crossed unescorted and followed a zigzag pattern to elude detection and tracking by enemy submarines prowling the shipping lanes. Likewise, Ed Imparato departed the San Francisco Port of Embarkation in January 1942, aboard the Navy transport USS *Coolidge*. The men on board, as part of the rapid emergency reinforcement of the South Pacific, had no idea of their destination or of their projected role upon arrival. The *Coolidge* sailed a zigzag course to Brisbane, Australia.

Jim Vitton sailed from San Francisco aboard a Dutch freighter, the HMS *Kota Agona*, with a Dutch captain and Javanese crew. "There's a song about a slow boat to China. It was not as slow [as our] boat," recalled Vitton. The vessel took 28 days to reach Finschaven, New Guinea. Once again, accommodations were less than luxuriant. "We were unescorted and had several thousand GIs aboard. The hold stank. The ship was filthy. Besides GIs it had a couple of Navy gun crews with some form of an artillery weapon aboard. Each day they would send balloons aloft and fire at them. They never hit one." The Navy gun crew Vitton remembered were a part of the armed guard, which sailed with merchant vessels in order to provide protection against enemy

Sam Speranza, 254th Infantry Regiment, 63rd Infantry Division, poses in front of a German "88," in Germany, 1945. An anti-aircraft artillery piece, this weapon was also used against Allied soldiers and tanks to great effect. It was one of the most feared German weapons. (Courtesy Sam Speranza.)

ships and aircraft. The lackluster performance of the crew on the *Kota Agona* might have given the GIs pause.

Johnny Campisi traveled to Australia aboard a Dutch freighter. The trip took an incredible 43 days as the vessel made stops at numerous ports in islands along the way. Tony Lima boarded the USS *Elliott* at San Diego in August 1944. Lima and his Marine unit, the Fifth Pioneer Battalion, was bound for Hawaii and more extensive training for the invasion of Iwo Jima (although the men didn't know it at the time). "The trip aboard ship was great; I had never been aboard a ship in my life until then, and I thought it was the greatest," recalled Lima.

Not all soldiers suffered in the holds of miserable converted freighters. Tony Cipriani departed from the New York Port of Embarkation on August 2, 1942, aboard the *Queen Mary,* and arrived off the coast of Scotland only five days later. Likewise, Bill Donofrio left Camp Myles Standish, Massachusetts, aboard a converted luxury liner, the SS *Mariposa*. Donofrio recalled, "Aside from being crowded (we were nine of us in a small room with just a toilet and sink), the trip wasn't bad, though some did get seasick. Two meals a day took up a lot of time, but it did leave time for card and craps games." Joe Jacovino met up with other talented soldiers aboard ship and began an entertainment group. "There was a small piano available, and we hauled it around from section to section. As a group, we turned into a fine entertainment unit," he recalled. Later, this group received formal recognition by the Army and became a GI entertainment unit. Ralph Barrale departed from Boston, Massachusetts, aboard the SS *Mt. Vernon* on July 1, 1944. Barrale, who was a military policeman (MP), said, "the voyage over the Atlantic Ocean was a pleasant one; my outfit being MPs [we] had to pull guard duty on ship. No rest for us. The second day out found a vast majority of the men at the rail, suffering from seasickness."

Paul DeCicco departed from Brooklyn in October 1944, aboard the troopship SS *James T. Parker*, a former cruise ship called the SS *Panama*. From the ship he could see the precise park bench where he and his girlfriend had spent many a happy moment. Housed in bunks five-high in the old swimming pool, DeCicco remembered his trip as uneventful. He worked in the galley and was able to "acquire" enough cans of sardines to supply his platoon during a 20-mile march from Marseilles to La Malle, France. Likewise, Sam Speranza left the United States on Thanksgiving Day, 1944, aboard the former Italian luxury liner *Saturnia*. Speranza, a platoon guide with the 254th Infantry Regiment, 63rd Infantry

Division, remembered that his company had K.P. duty during the 10-day trip. "Speaking a little Italian and French, I hooked up with a French chef who cooked for the officers," Speranza recalled. "I lived like a king for 10 days as he gave me the food [the officers] ate. Everything the troops ate was steamed."

Bill Dirienzo made a summer crossing on the *Sainte Marie*, a converted banana boat. He recalled that "the trip across the Atlantic was calm, just like a big lake, since it was summertime. . . . So, most of the GIs were topside telling stories, with plenty of card and dice games going on also." Charles Serio crossed the Atlantic on a troop ship in 1943, on his way to North Africa with the 995th Field Artillery Battalion. "It was 15 days without incident, thank God," he recalled.

Most Army Air Forces crew members flew their own aircraft to the combat theater. In November 1943, Sam Mastrogiacomo's crew flew their B-24 Liberator to England via the so-called southern route. Departing from an air base in Florida, they made overnight stops at American bases in Puerto Rico; Natal, Brazil; British Guiana; Dakar, French West Africa; and Marrakesh, North Africa, near Casablanca. There, they flew anti-submarine patrols for about 10 days before flying the final leg to their base in England. At each stop along the way, American airmen serviced and refueled the Liberator and prepared it for the next leg of the journey. Mike Ingrisano, a radio operator in C-47 troop carrier aircraft, flew to Europe via the northern route in 1943. Ingrisano, flying on a new C-47, recalled, "We left Baer Field [Indiana] on 3 August 1943. Flew the northern route toward Europe—Maine, Labrador, Greenland, Iceland, Ireland, England, North Africa, finally arriving at El Kabrit, Egypt, on 17 August, 1943."

Of course, even aircrew members were occasionally passengers in other vessels. Art Pivirotto, a Navy B-24 bow gunner, went overseas to join his squadron in England in December 1943. Instead of flying their own aircraft, Pivirotto and his crew sailed aboard a Navy seaplane tender.

Arrival

Combat soldiers could arrive overseas in one of two ways. They might arrive as part of a unit, slated to join a part of the United States forces engaging the enemy. Or they might arrive as a replacement and be sent to a replacement depot on the continent. From there they would be sent to a unit to replace a combat casualty sustained by that unit. The replacement system was designed to get men to the front lines quickly, and assignment to a "repple-depple" could be an unsettling experience. Men were sent directly to units in the front lines, and they had no opportunity to blend in and become part of the unit which had built its cohesiveness through many days in combat. Jim Vitton recalled receiving replacements in the Philippines in the summer of 1945:

We had good days and bad days. On the good days we gained ground but lost men. On the bad days we gained nothing and usually lost more men. We had replacements reporting almost daily, fresh off the boat with their yellow shipment numbers chalked on their helmets.

Such men were usually sent to the front lines with little or no additional training.

Sam Lombardo, an infantry officer, went into the front lines in Europe as a replacement platoon leader in the 394th Infantry Regiment, 99th Infantry Division, just before the Battle of the Bulge in November 1944. "It was very difficult to go in as a replacement," he recalled. He was suddenly in charge of almost 40 men who had already been in combat together and knew each other. "It was a real chore to get to know everybody—I made an effort to visit every foxhole," he said. With the help of a good platoon sergeant, Lombardo took care of his men.

Dave Azzari arrived in Naples as an infantry replacement in the summer of 1944. "Naples was beautiful," he recalled. Azzari spent one and a half months in the replacement depot there. "We bummed around; we had nothing

Frank Fantino is pictured after he was recalled into the Army, about 1950. (Courtesy Frank Fantino.)

Armand Castelli, 176th Finance Section, is pictured while on temporary duty at Manila, Philippines, from Naha, Okinawa, 1945. (Courtesy Armand Castelli.)

Al Miletta is pictured here in 2000. (Courtesy Al Miletta.)

to do." He was finally assigned to the 1st Battalion, 143rd Infantry Regiment, 36th Infantry Division, preparing for the invasion of Southern France. Azzari, who had gone through mechanized infantry training, ended up as a regular infantryman.

Charles Tortorello was drafted in 1943, at the age of 18. Sent to Camp VanDorn, Mississippi, he was assigned as a cannoneer with the 718th Field Artillery, and he completed basic training with that unit. He was then sent to a replacement depot overseas where, much to his chagrin, he was handed an M1 Garand rifle and given two weeks of infantry training. To his dismay, he fired expert on the M1 and was sent north to take on the *Wehrmacht* as part of the 88th Infantry Division. And just like that, he was transformed from an artilleryman into a rifleman, "ready" for combat.

Tony Pilutti arrived in England on May 16, 1944, and was assigned as a platoon sergeant in the 508th Parachute Infantry Regiment, 82nd Airborne Division. They immediately went into isolation in preparation for the coming landing at Normandy. Less than a month later, on June 6, 1944, Pilutti entered combat in harrowing style as the 508th jumped behind enemy lines in the black of night as a precursor to the D-Day landings.

Frank Fantino attended basic training at Camp Croft, South Carolina, and was trained as an armorer artificer—a weapons repairer. Scheduled for shipment to Italy, he missed two departures and was finally sent to New Guinea. There, he was placed in a heavy weapons squad as an ammo carrier, never to put to use his armorer training. Al Panebianco, trained as a clerk-typist, arrived in Italy only to be sent to the 157th Infantry Regiment of the 45th Infantry Division. Panebianco recalled that the "45th needed men regardless what you were trained for. I was assigned to the weapons platoon, 60

mm. mortars. I [had never seen] a mortar. I became an ammunition bearer. Talk about hitting a new low. I was very unhappy but adjusted to conditions."

Tony Mastrogiacomo went to England in 1944, as part of the 291st Infantry Regiment, 75th Infantry Division. At that time, the Army needed replacements badly and pulled men from rear echelon jobs to fill front-line riflemen positions. Mastrogiacomo recalled that about one-half of his company was made up of men transferred from Air Forces units. Still, even those men performed well in combat, and Mastrogiacomo paid them a compliment: "They were a bunch of swell guys; there were none better."

Not all classification and assignment changes involved sending untrained clerks into combat as front-line riflemen. Armand Castelli was drafted toward the end of the war and trained as an infantryman. He was then sent to Okinawa to await participation in the planned invasion of Japan. "They told us we had to establish and hold a beachhead 15 miles by 5 miles for six hours, and that about 40 percent of us would come back in boxes," he recalled. Fortunately, the war ended before an invasion of Japan became necessary, and Castelli was transferred to the Finance Department where he became a clerk in the disbursing office.

For some men, their arrival overseas was also their introduction to combat. Amiello Lauri, who spent 23 seasick days aboard the troopship, arrived overseas in the midst of an air raid. Although he could not recall his exact docking location, he remembered that it was "at the height of a massive German air raid; needless to say, I was scared stiff. Ack-ack shrapnel was falling all around us; I took cover under a nearby truck. When the air raid was over, I couldn't get out from under because my field pack was hung-up on the under carriage; they had to jack the truck up to get me out. I took quite a ribbing before that blew over."

Likewise, Al Miletta, an aircraft armorer in the 81st Fighter Group, arrived off the coast of North Africa in November 1942. "We disembarked over the side on ropes with full gear and heavy .303 World War I rifle," recalled Miletta. As the men scrambled down swaying rope ladders toward the pitching landing craft, an officer aboard ship yelled down and asked what the men were. The soldiers, who were all airplane mechanics and support personnel, replied that they were Air Force. "Well, you're infantry now!" the officer replied. "That was a stomach-churner," Miletta said. The landing craft, loaded with about 30 soldiers, headed for shore. Miletta remembered that, "the coxswains were quite young and wouldn't go in too close to shore. I was the second one off the boat, and the water was up to my chest. We hit the beach and dug in, then we started inland; we had no casualties." Others weren't so lucky. Their boats were either fired upon or capsized. Miletta and others helped drag bodies ashore; "It left an impression I will never forget."

Dom Constantino had a much better reception at his port of arrival. A coxswain aboard the USS *Pinkney*, Constantino arrived at Pearl Harbor, Hawaii, in December 1942. The *Pinkney* was loaded with supplies, including the first whiskey to arrive in Hawaii since the war started. Constantino and company were met at the harbor by hula dancers and bands. Unfortunately, the *Pinkney* picked up supplies and left for the war zone two days later.

Charley Tortorello, the artillery cannoneer who ended up in the infantry, recalled being issued standard items in the replacement depot: ammunition bandoleer, backpack, and a mattress cover. Upon inquiring as to the use of the mattress cover, he was told that if he became a casualty, the Graves Registration Unit would place his remains in the cover to be picked up later. Tortorello said, "Along the route north there were many discarded items; topping the list were mattress covers—who wants to carry their own casket?"

Vince Consiglio's move from Plymouth, England, to France just after D-Day was far from routine. Consiglio's unit, the 291st

Engineer Combat Battalion, had built a steel runway for the Air Forces at Plymouth, and they had repeatedly been alerted for shipment across the channel. Each time, Consiglio had packed his bags, and each time the men cooled their heels in a transport that waited in the bay, never leaving for France. During one such alert, Consiglio didn't pack all his clothing, leaving most of it in the barracks; this time, the transport left England and headed for France. Upon arrival off the Normandy coast, Consiglio was the passenger in a jeep as it departed the landing craft. Instantly, Consiglio found himself in water up to his neck. "The Air Corps had bombed the beaches prior to the invasion, and we had driven into a bomb crater just off shore," he remembered. And thus did he arrive in France, without all his belongings and with those in his possession completely soaked.

Bill Donofrio, who had been trained as a tanker and ended up as a rifleman in the 70th Infantry Division, described his trip to the front. Arriving in Marseilles, France, in December 1944, he was shocked at the devastation in the harbor wrought not only by American bombers, but by retreating Germans as well. For their move north to the front, Donofrio and his unit . . . :

. . . loaded into trucks then drove high into a hilly area where we pitched our little two-man tents. Rocky ground and bitter cold winds made that difficult and sleeping even more so. About a week later, we loaded onto old French 40 and 8 box cars for a miserable four-day trip north to the front. No latrine facilities made bodily functions suffer. At random times, the lengthy train would grind to a slow stop and we'd quickly jump off to relieve ourselves. One time it was in the train station in the city of Lyon. Civilians watching didn't stop anyone.

Jim Vitton arrived in New Guinea as a replacement in late 1944, direct from the United States. Bound for combat in Leyte, he still had to undergo processing in New Guinea. He recalled: "As we disembarked, we were assigned to a tent and then, of all

things, were given a physical, including a 'short arm' inspection [for venereal disease]. . . . I don't know how we would have picked up a venereal disease on the boat as we had a 'short arm' just before leaving Frisco." Next on the agenda was a dental examination. Vitton remembered the examination:

I had very bad teeth. They would crumble. [In basic training,] a dentist colonel pulled eight and put in 20 fillings. He gave me his card and asked me to write him as to how the teeth did. He said some of the fillings were experimental. Upon getting my physical in New Guinea, I already had seven additional cavities. I was referred to the tent where the dentist was. The drill for the dentist was operated by virtue of a sergeant astride a bicycle. His pedaling provided the impetus to operate the drill. As I was being worked on, several times the drill would quit because the sergeant wasn't pedaling fast enough. The colonel would yell at him to increase speed. He would do so; the drill would begin again with a BZZZZZZ that I can't describe but would raise me right out of the chair. I never wrote to the stateside dentist regarding the teeth. A howitzer shell landed alongside my foxhole one night on Leyte and blew my pack up, including the dentist's card.

Vitton was then sent to Leyte Island, Philippines, and assigned to the Assault Platoon, D Company, 128th Infantry Regiment, 32nd Infantry Division. As Vitton recalled, the Assault Platoon was . . . :

. . . supposed to be called upon when the regular infantry unit got hung up in trying to take a position from the enemy. We supposedly were expert in automatic weapons, flame throwers, demolitions, etc. It really didn't work out that way. Essentially we were just another combat platoon. It gave us a strutting position, however. We were THE ASSAULT PLATOON. That's kind of like being the teacher's pet. Also, it was a good way to get hurt or killed.

John Mangione also made the trip from New Guinea to the Philippines. Mangione's field artillery unit was aboard a Navy LSM

(Landing Ship, Mechanized) in the midst of "a monstrous convoy." En route, kamikazes attacked the convoy. At one point, Mangione's LSM broke down, and the convoy left them. "That was very hairy," he remembered. The crew managed to repair the LSM the next day, and they eventually caught up with the convoy. "We were lucky," Mangione said.

This is John Mangione, 1st Field Artillery Battalion, 6th Infantry Division, Pacific Theater of Operations. (Courtesy Jon Mangione and John Mangione.)

Living Overseas

Generally, men lived overseas and trained with their units before entering combat. Arriving in Bristol, England, in July 1944, as part of the 510th Military Police Battalion, Ralph Barrale remembered that his duties included "police patrolling and Castle Guard of the Ninth United States Army." Vince Consiglio arrived in England well before D-Day. His unit, the 291st Engineer Combat Battalion, moved through southern England, reinforcing bridges in preparation for the massive movement of heavy military vehicles to ports on the English Channel for the invasion.

Sam Mastrogiacomo, serving with the 702nd Bombardment Squadron in the 445th Bombardment Group in England, had the opportunity to fly with a Hollywood legend. Major Jimmy Stewart, Academy Award-winning actor, was the commander of the 702nd's sister squadron, the 703rd Bombardment Squadron. Stewart flew with Mastrogiacomo's crew as a check-out pilot. "He was a heck of a nice guy," Mastrogiacomo recalled. Once, Mastrogiacomo returned to base after curfew, at midnight. In trouble, he had to go before Stewart for disciplinary action. Mastrogiacomo recalled, "Stewart rubbed his chin and said, 'I hate to interfere with your social life, but you know when you're supposed to be back to base.'" With that, the incident was closed.

Mastrogiacomo didn't have much time to associate with the local British people, although some of his ground crew did. He spent seven days in Scotland following a particularly harrowing raid, and he said, "I got to know some of the Scottish people and if you called them British, they were highly insulted. They would insist they were Scottish, not British. They were very nice to us, and couldn't do enough for us." Although friction between the Americans and the British was inevitable, in the end, all pulled together for the common good.

Mastrogiacomo recalled how this manifested itself among the British. "When we first got over to England, the Brits would refer to us as the Yanks (for example, 'The Yanks bombed the railroads at Frankfurt,' or 'The Yanks bombed the submarine pens in Hamburg'). After two months, they would say 'Our boys' bombed the aircraft factories. They accepted us as family. We were one of them."

C.J. Lancellotti, serving in England with the 137th Signal Radio Intelligence Company, recalled visits to the local village on Salisbury Plains in 1944: "After duty, we wandered around the small town packed with soldiers looking for something to do. There wasn't much." After his unit moved to Dartford, England, in June 1944, Lancellotti had better luck. During one pub visit, he met a young girl who would later become his wife.

Lancellotti described his unit's billeting arrangements on a college campus in Dartford:

The college consisted of a couple of large buildings where the enlisted men were billeted. The officers were billeted in a separate building, which also contained a swimming pool. The front entrance to the complex contained a small building, which we used as a guard shack when on guard duty. There were underground bomb shelters at the rear of the complex where some of the men slept during bomb alerts. The bombing at this time came from the new German V-1 rockets, which came from various parts of the continent and flew right over Kent on the way to London. Several struck the Dartford area. When this occurred, the 137th assisted the English Civil Defense team in rescuing wounded and clearing up V-1 bomb damage. We also continued training for our mission we would perform when we crossed the channel to France.

In August, Lancellotti and his specialized unit moved to France to begin their mission in support of the advancing Allied armies.

When Johnny Campisi and his unit arrived at Cairns in northwest Australia, they found almost no facilities available for their use. The men set about building barracks and other facilities themselves. At first the Australians living nearby were quite suspicious, but they eventually grew to accept the Americans. "The Australians were wonderful people, full of hospitality," recalled Campisi. Dave Azzari felt that the people he met in rural southern France were very nice, although those in Paris were less so. Tony Pilutti also recalled that the French were, in general, "not very cozy—more or less indifferent." The people he met in Holland, however, "were very nice, they couldn't do enough for us." Jim Vitton met natives of New Guinea while stationed there. "It was disheartening to see the New Guinea people. They were thin and emaciated. They wore clothing only over their privates. They were covered with sores. Maybe they weren't all like that but those in our area were," he recalled. Vitton also recalled an incident illustrative of the clash of cultures inevitable whenever troops deploy to foreign lands. Walking through a Philippine village one day, Vitton saw "a lady ahead of me with a basket of fruit on her head. Suddenly she put the basket down, squatted down, raised her skirt and did her business right there on what would constitute the main (only) street. She saw me. She wasn't embarrassed. I was."

Often citizens living in the war zone expressed their gratefulness even in their own want. When Vince Consiglio's combat engineer unit drove through small French villages, the people would often come out and give bread to the American soldiers. "They were so happy," Consiglio said of the villagers, "they had nothing, the poor things." Bill Dirienzo, an infantryman in the 30th Infantry Regiment, 3rd Infantry Division, recalled the bottom line of military/civilian interaction in his experience in Italy and France: "Relations with the local people was mostly on an economic basis. They needed food, and the GIs had the food. They would do most anything to get it, just so they could survive—including sex." He

Mike Altamura is shown with his half-track, Skunk Hollow. He was part of the Maintenance Company, 750th Tank Battalion, Germany, 1945. (Courtesy Mike Altamura.)

saw children in Italy fishing through the 55-gallon drums the soldiers used as garbage cans, looking for edible scraps. "Naturally, the guys would make sure the kids caught the food before it went into the barrels, even though we had orders to ignore [the kids]. Every so often some high brass would come around and make them all clear out of our areas," he recalled. Dirienzo always gave the chocolate bar from his D ration to local children. He said, "In all the time I was there, I don't think I ate one of [the bars] myself. They were too hard anyway."

Food wasn't the only item of subsistence to change hands among the soldiers and civilians. Again, Bill Dirienzo recalled: "Going through Southern France, the people would greet us on the roadways as we entered the towns with different offerings. Naturally, there was a lot of wine and cognac. Being in the infantry, we had so much to carry that we couldn't take a lot of the offerings. Some of the guys would take a bottle of wine and some bread and have it as we were walking to our next objective." Mike Altamura had an advantage in this regard in that he could—

and did—use his half-track, *Skunk Hollow*, to carry "liberated" cognac.

Charley Tortorello recalled a poignant episode during his duty in Italy:

While the German troops occupied Italy, it was apparent they told the civilians that the Americans were monsters and that if they ever took the country that they would take all their food and animals, rape their women and other atrocities. This so frightened the people that one time we liberated a village, we could hear a child's cry; on investigating, we found a cave which held about eight people: three women and five kids, no men. It was dark, and when our sergeant played his light in there the children screamed as if we were going to kill them; they were in panic and we had to physically embrace them to calm them.

Another time, Tortorello recalled that a barrage of fire from a German 88 mm. anti-tank gun badly wounded one of the mules in a mule train. Tortorello described the ensuing scene: "While that mule was still kicking on the ground, out of nowhere came *paesani* with butchering equipment to feast; Lord knows how long it was since they had any meat."

Civilians in the combat zone could also provide information of vital importance to American troops. Bill Dirienzo recalled an incident in southern France: "In one town a woman came running up the road crying and saying that we shouldn't go down the road any further. Sure enough, we went around the area and later, the engineers found a lot of personnel mines. In general, the people were very kind and helpful to the liberating troops." Dirienzo also remembered the Germans he encountered: "When you talked to the people, none of them were Nazis. In general, the *Wehrmacht* and civilians gave us no trouble. They were more tired of the war than we were."

Chapter 5

COMBAT

Initiation into combat was another milestone in a serviceman's life. Now all their training and mental and physical preparation came to bear in one moment. For men in combat, there was the ever-present threat of death—death that could come in a terrifying number of ways, swift or lingering.

Usually, men moved forward into the combat zone gradually as they progressed from the port to the front lines. Bill Donofrio recalled his movement to the front lines in December 1944:

Signs of recent fighting became more evident as we went north. We got off the [rail] cars on Christmas eve loaded with full field packs, and after several hours of marching ended up in an abandoned factory. En route, we could hear and see flashes of artillery in the distance. That and the sight of three graves with German helmets at roadside gave us a lot to think about. Christmas in the town of Bischweiler in Alsace was a far cry from ours in America; C Rations [were the] special of the day.

Soon, Donofrio arrived at the front lines. "On December 28th, we actually went on the line right on the Rhine River directly across from German pillboxes. There we could see Krauts moving among them. I tried to pick one off, but my platoon leader, Lt. Meshier, said, 'Don, all you hit was Germany,'" he recalled.

Tony Pilutti parachuted into combat near Chef-du-Pont, behind Utah Beach in Normandy, in the early morning hours of D-Day, June 6, 1944. He recalled watching German ground fire directed at the incoming aircraft. Each tracer round appeared headed for Pilutti's airplane, only to curve and miss at the last second. Pilutti recalled that a C-47, fully laden with fellow paratroopers, took a direct hit and exploded nearby. Pilutti's unit, the 508th Parachute Infantry Regiment, was widely scattered during the jump and met only minor resistance as men joined into fighting groups on the ground. Pilutti recalled that his combat load came to about 75 pounds. "I carried hand grenades and explosives; plus, we carried detonating caps around our helmet. If they went off, they'd take your head off. But we had no where else to put them," he recalled. Pilutti landed about 50 feet from a river. Others weren't so lucky and landed in rivers or ponds, drowning horribly under the weight of their gear.

Pilutti and his unit came off the firing line on July 16, 1944. Back in England, an offer arose for United States servicemen who were not American citizens—anyone who wanted to obtain citizenship could do so. Pilutti, who had been briefly detained as an enemy alien before shipping overseas, reported to the American Consulate in Lichfield, England, and there, along with 22 or 23 other non-citizen soldiers, mostly Germans and Italians, with a few Poles, took the oath of allegiance. "It was one of the proudest moments of my life," recalled Pilutti of the ceremony as the men stood at attention and were granted citizenship.

It was, therefore, as an American citizen that Tony Pilutti next entered combat in September 1944, at Nijmegen, Holland, during Operation MARKET-GARDEN. Pilutti jumped out of the troop transport at about

This is Tony Pilutti, 508th Parachute Infantry Regiment, 82nd Airborne Division, Germany, 1945. (Courtesy Tony Pilutti.)

Mike Ingrisano, 37th Troop Carrier Squadron, is pictured on his C-47 on June 5, 1944, before taking off to drop paratroopers on D-Day. Note the parapack containing supplies for paratroopers under the belly of the airplane. (Courtesy Mike Ingrisano.)

500 feet. "The ground seemed awful close," he recalled. Pilutti was hit and wounded by a piece of shrapnel as he descended. The jagged, deadly piece of metal hit and tore up his harness, which probably saved his life. Once on the ground, he briefly sought medical aid, then continued his duties. It wasn't until later that he would be evacuated to an American field hospital in Rheims, France. The hospital there treated Americans and captured Germans. Right beside Pilutti lay a German soldier who had been shot in the buttocks and now was moaning and groaning. "I told him to shut up; it wasn't very polite of me," recalled Pilutti. Pilutti was eventually sent to a hospital in England for further recovery.

Like Tony Pilutti, Mike Ingrisano experienced combat for the first time during

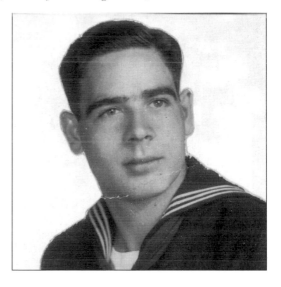

Domenick Porcaro, U.S. Navy, 3rd Fleet, 1945. (Courtesy Domenick Porcaro.)

Mike Ingrisano (third from left) and his crew, 37th Troop Carrier Squadron, are pictured just before taking off for Operation MARKET-GARDEN, September 17, 1944. Left to right are: John Harmonay (copilot), Bill Prindible (pilot), Ingrisano (radio operator), and Julius Ziankiewicz (crew chief). Note the chalk position number "24" on the fuselage. (Courtesy Mike Ingrisano.)

D-Day. Ingrisano, who had spent several months flying supply and training missions in the Mediterranean Theater, was a radio operator aboard a C-47 of the 37th Troop Carrier Squadron. "As we approached the coast of France at about 12:30 a.m., 6 June, I could see all sorts of flak coming up from the German land batteries," he recalled. "We dropped the 505 Parachute Infantry Regiment into Ste. Mere. Eglise." Ingrisano flew many follow-up missions to Normandy, bringing in supplies and hauling out casualties. He also flew during Operation MARKET at Nijmegen, Holland. On September 17 and 18, 1944, Ingrisano's crew dropped paratroopers and the fabric-skinned CG-4A tow gliders full of infantrymen. Ingrisano recalled the combat:

On the 18th, as we flew across the coast of Holland, we were followed by two 88 mm. which fired randomly, knowing that if they got close, their shrapnel would surely penetrate the cheesecloth of the CG-4A. As we flew down the canal, we noted that the fighter planes had not knocked out all the flak guns sitting on the barges. As we got close to our landing zone, I was suddenly pulled up by a line of fire right over my head. I jumped up, ran across the aisle to the navigator's position, and looked down.

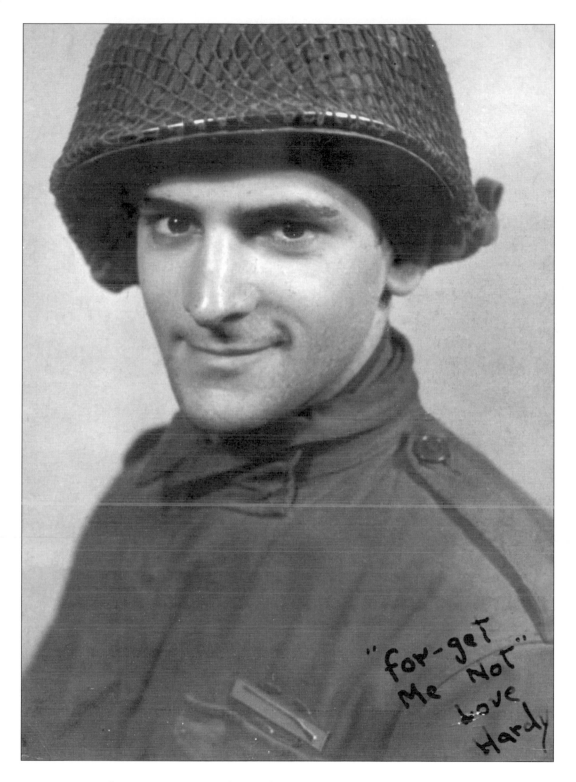

Warren "Hardy" Sorrentino is shown here. (Courtesy Veronica Smith and Warren Sorrentino.)

Sam Speranza, 254th Infantry Regiment, 63rd Infantry Division, is pictured on the bank of a river in Germany, 1945. "Our last battle, thank God." (Courtesy Sam Speranza.)

I could see this German soldier, blonde-headed, no helmet, and with a big smile on his face. Every time he squeezed the trigger, I could sense the bullets coming into the cabin. No body hits. After we cut our glider loose, the skipper called me up to the cockpit, we were heading for the deck. He spotted a German machine gun nest in our line of exit. Told me to grab the tow line release, and when he yelled, to let it fly. We couldn't kill any Germans, but we could sure give some a bad headache.

Warren Sorrentino, a platoon sergeant with the 112th Infantry Regiment, 28th Infantry Division, entered combat at Normandy soon after the D-Day landing. Sorrentino recalled,

It was an eerie and very scary feeling. You try to keep yourself composed and do the best you can under the circumstances. We were trained well, tried to out-think the enemy and keep yourself alive. . . . Getting off the LST, you could hear the firing from

the enemy and the American troops and of course you could see flames in the distance. There are no words to express the thoughts that run through your mind at a time like this. I remember thinking—God, let me live through this.

Vince Guzzardi was a fighter pilot with the 53rd Fighter Squadron. He recalled that his duty overseas was "to destroy anything that got in our way." His unit flew their P-47 aircraft in a tactical role. "Our main mission was to clear the way for our troops and destroy convoys, railroad yards, locomotives, airfields, supply depots, manufacturing facilities, tanks, etc.," he remembered. "On entering combat, [I] was very apprehensive but soon got over that by the second mission," he said. "At age 20, you are invincible!" Sam Speranza, an infantryman in Europe, remembered the fear, but also a desire to do his duty properly upon entering combat. "Fear, not knowing what to expect, and not to do anything foolish," he said.

Tony Lima is pictured in Washington D.C., November 1998. (Courtesy Tony Lima.)

Tony Lima remembered his initiation into combat on Iwo Jima with a Marine Corps Pioneer Battalion. On February 19, 1945, after the traditional early morning steak and eggs breakfast, the men boarded landing craft "and proceeded to the staging area in preparation for our run into the island of HELL." Lima was amazed at the scope of the invasion. "As we were circling in our landing craft, I finally realized how many ships were involved in this Iwo Jima operation . . . as far as I could see, there were nothing but ships, and all the shells that they were firing onto that island, we did not think that anyone could live through all those barrages." Finally, the craft began their approach to the beach. "When our turn came to start for the beach . . . in all honesty, I was not afraid . . . that would soon change. Our LCT landed on the beach with the sixth wave at approximately 10:00 a.m.; now you want to talk about being scared . . . there were Japanese artillery shells, mortar shells, grenades, rifle fire constantly with no let up. To top it off, the black sand was so slick that we had an awful time trying to dig a foxhole,

and all the while Marines were being killed at an awfully high rate."

Lima's duties at Iwo Jima consisted of unloading supplies and equipment from the ships, setting up ammunition dumps, setting up food and water dumps, and delivering food, water, and supplies to the front lines. "My training was as a water purification supply man, and my duties were to purify the ocean water for drinking and for showers for the Pioneer Battalion only . . . unfortunately, things were so bad on the beach that they could not bring my equipment in . . . so I became a runner for one of our officers," he recalled. In early March, the men of the Pioneer Battalion were sent to the front lines to replace Marines who had been killed or wounded. "One day, our company had some Japs trapped in a ravine, and after a while they threw a note up to us which was attached to a large stone saying they wanted to surrender. . . . Some of them did surrender, and the others met their ancestors," Lima remembered.

Ed Imparato, a C-47 pilot in Australia, first saw combat as he flew cargo missions into

John Mangione, 1st Field Artillery Battalion, 6th Infantry Division, is shown firing one of his battery's 105 mm. howitzers in the Philippines, 1944. To offset the concussion, gunners had to open their mouths to equalize pressure on the eardrum. (Courtesy Jon Mangione and John Mangione.)

Darwin, Australia, while that airfield was under Japanese attack. This was such a common occurrence that aircrew members approaching Darwin had to radio the control tower for instructions and to find out if the airfield was under attack. Often these cargo planes returned to Melbourne with a cargo of wounded soldiers being brought back to hospitals. On missions into New Guinea, the crews flew over territory so desolate and remote that there were no maps generally accessible to them. Often they flew with Australian gold miners who were familiar with the area as guides. Eventually, they received USAAF navigators as crewmembers.

John Mangione's first combat action was at Wadke, New Guinea, with Battery B, 1st Field Artillery Battalion. They came ashore with minimal resistance, set up their battery, and began pounding away at targets well out of visual range. Dave Azzari's introduction to combat came as a member of the 143rd Infantry Regiment of the 36th Infantry Division at Sainte Raphael during the invasion of Southern France. He recalled that his company deployed into a vineyard that contained large, juicy grapes. "We gorged ourselves, and the next morning the entire company had diarrhea." Despite this, his unit advanced and captured many Germans, equipment, and enemy railroad guns. Charles Serio, a radioman with the 995th Field Artillery Battalion, recalled his first combat in Italy when enemy aircraft attacked his unit. "We set up our guns and soon got a taste of strafing. It didn't take you long to find a hole," he remembered. Patrick Molinari, an infantryman with the 276th Infantry Regiment, 70th Infantry Division, recalled that he was "just plain scared" as he entered combat during the last part of the Battle of the Bulge.

Jim Vitton, while stationed in New Guinea awaiting shipment to combat at Leyte, Philippines, had his first taste of enemy action. He recalled, "At night we were visited by 'Washing Machine Charlie.' That was the name for the Japanese plane that came over and dropped bombs at random. None came close to our area, but they certainly kept one awake." Dom Constantino, serving aboard a troop transport during numerous Pacific island invasions, also reported contact with Washing Machine Charlie. Mike Altamura reported a similar encounter in Europe with a German liaison plane they called Bed-Check Charlie.

Art Pivirotto was a bow gunner in a Navy B-24. Flying from Dunkswell, England, Pivirotto and crew flew long-range anti-submarine and anti-shipping patrols over the Bay of Biscay, France. The planes flew to the bay escorted by British Spitfires. Their chief adversaries at that range were the long-range German Ju-88 aircraft. Once on station, however, the B-24s were on their own; the missions were hazardous and very long—sometimes more than 10 hours in duration. The B-24s were

Patrick Molinari, 276th Infantry Regiment, 70th Infantry Division, is shown at right with a friend, somewhere in Germany, 1945. (Courtesy Ken Molinari and Patrick Molinari.)

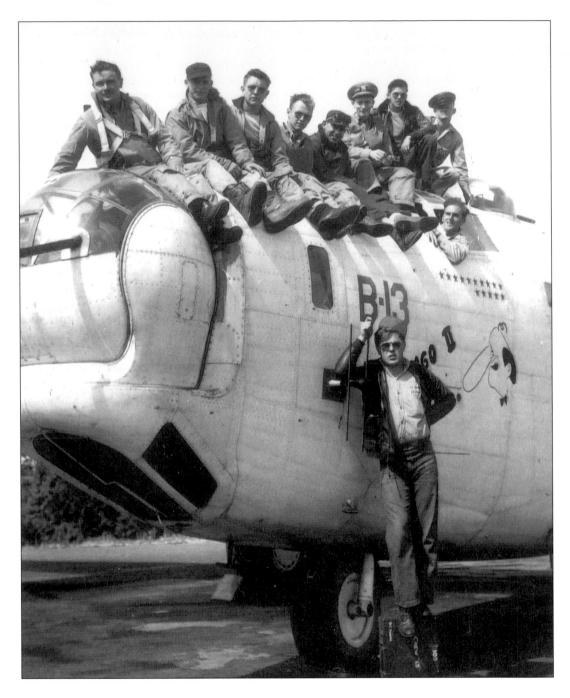

Art Pivirotto (front, below B-13) and the crew of the Navy B-24 Umbriago II are pictured here. Left to right are: Lt. Cmdr. Whitmore, pilot; Rieth, tail gunner; Pfeiffer, waist gunner; Lt. J.G. Kinder, co-pilot; Willet, waist gunner; Ens. Gahagen, navigator; Williams, 2nd radio; Riddle, crew chief; and (in window) Werner, 1st radio. (Courtesy Art Pivirotto.)

equipped with radar to find surfacing submarines or blockade-runners. Once the Americans pinpointed enemy vessels, Pivirotto and crew attacked them at low-level. Depending upon the mission, the B-24s would attack using guns, depth charges, or other air-to-ground ordnance. After completion of the mission, Pivirotto and crew were escorted back to England by night-fighters. Pivirotto flew 46 such grueling missions.

Tony Mastrogiacomo, who, with his twin brother Pete, served in the same squad in the 291st Infantry Regiment, 75th Infantry Division, entered the front lines in December 1944, in Belgium. For three weeks, the men slept in foxholes; then they were given a rest break. "We slept on the floor in a house, and it felt like the Waldorf Astoria," recalled Mastrogiacomo. Their rest was brief—only one day. The Germans began their offensive in the Ardennes, and Mastrogiacomo's unit had to hurry back to the front lines. The men marched in freezing weather from six in the morning until eleven at night. "The Belgians treated us kindly; we traded our C rations for hot soup," he remembered.

Mastrogiacomo reached the front lines and went into action. At one point, they were so close to the Germans that they could hear them starting their tank engines and could even hear their conversations. Soon Mastrogiacomo's unit was ordered to attack the Germans on a stretch of high ground, approaching the enemy over a snow-covered field. "We were supposed to get white coats [for camouflage], but we never got them. Can you imagine attacking through snow with brown coats, what great targets we were? The Germans were knocking guys off like crazy," he recalled. Mastrogiacomo was pinned down about 50 yards from the Germans in the woods. "Guys were getting hit left and right, dying all around me," he remembered. Despite the onslaught of machine gun, rifle, and mortar fire, Mastrogiacomo remained calm, remembering the lessons he learned from

the Alaskan combat veterans he had trained with.

Pinned down in the snow, Mastrogiacomo began to freeze. His boots were soaked. "It was so cold, I had to put my hands on the barrel of my M1 [rifle] for warmth after firing it," he remembered. "I told myself, 'Play dead, pray, think of home, and don't panic,'" he recalled. He waited until dark and then began to crawl back toward American lines. Along the way, he managed to drag a wounded man back with him. Once he arrived back at his unit, he inquired about his brother, Pete. Someone said he thought he saw Pete get killed. Mastrogiacomo recalled how he took this devastating news: "I thought, 'I'm never going back home.'" Frantically, he began a search of the dead Americans in the area, using a flashlight to find his brother's body. He was unable to locate the body, but found a man who said he saw that Pete was only wounded, having been shot in the shoulder and taken away in an ambulance. Greatly relieved, Mastrogiacomo began to march back to the front. It wasn't long before a medic saw Mastrogiacomo and another man limping painfully along the road. The medic inspected their feet and saw that they were turning blue. "You've got frostbite," he said. "You're going to the hospital." With that, the medic put a yellow tag on Mastrogiacomo and loaded him into an ambulance for the trip to the rear.

Although riding to the rear in an Army ambulance, Mastrogiacomo's troubles were far from over. Germans began shelling the road, and soon the ambulance was blown into a ditch. The driver died, with three large shrapnel holes in his back. "He was a big, strapping, good-looking Italian kid," Mastrogiacomo recalled. Medics forced German POWs to carry Mastrogiacomo to the field hospital in the rear. Once in the hospital, medics washed Mastrogiacomo, gave him clean clothes and clean sheets, and gave him a big bowl of hot chocolate. "This is living," he thought. Even rear areas and field hospitals were not completely safe;

Mastrogiacomo's area was often attacked by German buzz-bombs. Soon he was evacuated to a hospital in Paris, then on to Wales.

In the hospital in Wales, doctors said they'd have to amputate Mastrogiacomo's toes because of the frostbite damage. This news devastated Mastrogiacomo. However, as he was brooding, he saw men all around him who had been badly shot-up, and he came to the conclusion that he was not that bad off. Soon, color came back to his toes, and he didn't lose them. Mastrogiacomo ate steak and eggs and was given cigars and cigarettes—a far cry from the front-line combat conditions he had been used to. "We ate like kings," he recalled. "You could have anything you wanted." The best news, however, came from the Red Cross who found his twin brother Pete. It turned out that Pete, wounded at the same time as Tony, was in a bed only two wards away from Tony. Visiting his brother, Tony was happy to see him doing well, even though he had a full

Pete Buongiorno, 30th Infantry Regiment, 3rd Infantry Division. (Courtesy Pete Buongiorno.)

Dom Constantino is pictured aboard his landing craft (left-center, back to camera, with sailor hat), Pacific Islands, 1944. USS Pinkney *is in the background. (Courtesy Dom Constantino.)*

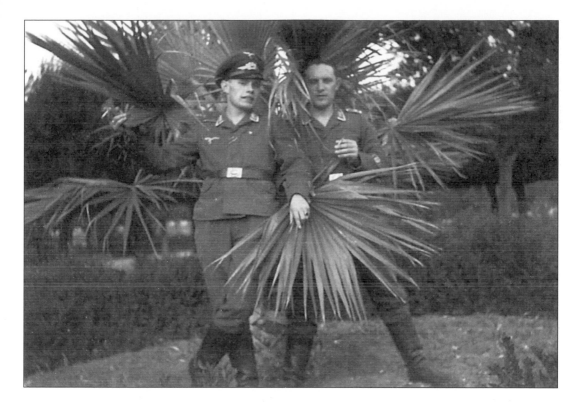

"Captured German photo, Luftwaffe officers in Italy, 1943." (Courtesy Mike Altamura.)

cast on his arm. This joy was dampened, however, by the news that the men's uncle had been killed in action during the same battle in which they had been wounded.

Pete Buongiorno, an infantryman with the 30th Infantry Regiment, 3rd Infantry Division, was wounded in Germany only a few days before the end of the war in Europe. In the early morning hours of April 28, 1945, Buongiorno's squad was advancing toward Augsburg, Germany. "All of a sudden all hell broke loose with shell fire and machine gun fire," he recalled. The men took shelter under the steps of a concrete footbridge they needed to cross. "We got under the steps and shells, and fragments are flying all over. You can hear the pieces hitting the walls and the ground," Buongiorno remembered. He charged over the bridge and then sought cover under the steps at the far side. Buongiorno related what happened next:

I laid on the ground, and shells are exploding all around. I was there for about five minutes when I was hit in my right foot, and I was scared; I thought my foot was badly damaged because when it hit, it was like someone hit me with a big hammer, and plus my foot had a burning feeling. I yelled medic but they were all busy taking care of other guys who were hit. I laid there and tried moving my foot to see if it was OK. I had pain, but it seemed OK.

A captain who was also under the steps asked Buongiorno to escort two German prisoners to the rear on his way to the aid station. Buongiorno said:

When there was a slight lull in the shelling, I got the Germans—or Krauts as we called them—and told them to move back over the bridge. I limped as I ran to get to the other side and got safely under the steps again. I finally got back to the medic station where this captain looked at my foot and said you have to go back to get it X-rayed to see if any pieces of shell was in my foot. I

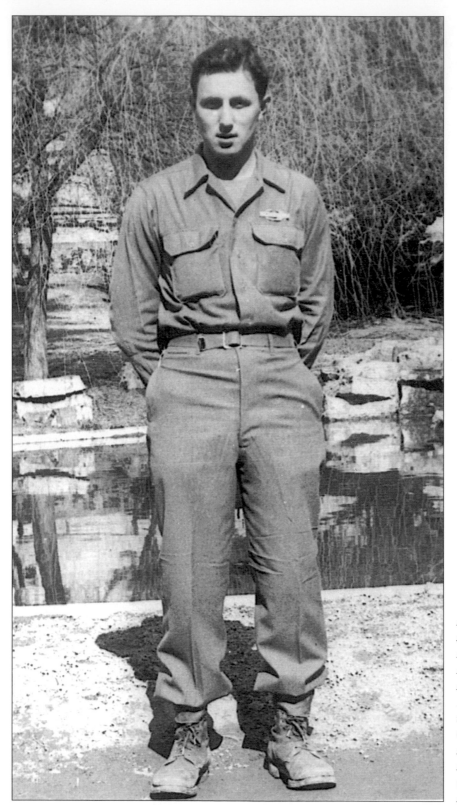

Dave Azzari is shown here in Bains-les-Bains, France, December 1944. Azzari is wearing the Combat Infantryman Badge. (Courtesy Dave Azzari.)

was in this house 'til about nine in the morning, when they took me back to a field hospital. From the field hospital to a hospital in central Germany. In all the places I stayed they treated us great.

Vince Carnaggio was a Navy machinist mate aboard landing barges, the Higgins boats known officially as LCVPs. One of a three-man crew, his duties were to man .30 caliber Browning machine guns and to raise and lower the landing ramp. His introduction to combat came in November 1943, at Tarawa in the Gilbert Islands. He watched from his vessel as battleships, destroyers, and cruisers shelled the beach. "I thought, 'This is going to be a piece of cake.' Well, it wasn't a piece of cake," he recalled. He made three or four trips from his assigned troop ship to the beach, hauling Marines assaulting the island. "The carnage on the beach was terrible," he remembered. Seeing plenty of wounded Marines planted the idea in his mind that he wanted to try to help people in the future. Another Navy coxswain, Dom Constantino, remembered his first taste of combat. As his ship passed by some Japanese-held islands, he and two friends leaned over the railing looking for signs of Japanese activity on one of the islands. After peering at the island for some time, Constantino looked up to see that he was alone; his friends had fled. He looked skyward in time to see two Japanese aircraft in the process of beginning an attack on his ship. He took off running for shelter below deck where he heard the sounds of the Japanese bombs exploding.

Constantino later became a ship's cook aboard the USS *Pinkney*, a troop transport. As ship's cook, Constantino was responsible for running the mess hall on the *Pinkney*. He made sure the food was kept hot and that everything was kept "clean and pleasant to look at—and some of the food wasn't," he recalled. Constantino made lemonade and iced tea for the troops they were transporting. On the morning of an invasion, Constantino and crew made steak and eggs for the troops scheduled to hit the beaches.

The soldiers would ask, "Are you trying to tell us something?" Constantino lamented: "It was the last meal for some of them." Once, Constantino met some of his Italian-American friends from his neighborhood in Worcester, Massachusetts, as they came through the chow line. He told the men, who were among the Army troops the *Pinkney* was transporting, to return to the mess hall at 8:00 that night. "I had set aside some ice cream and other stuff; we had a nice party and talked about old times," he remembered.

During the invasion of Okinawa in April 1945, Constantino survived a kamikaze attack on the *Pinkney*. Arriving off Okinawa on April 1, 1945 (Easter and April Fool's Day), the *Pinkney* discharged her troops and waited off shore. The men were subjected to nightly Japanese air attacks. On April 28, Constantino and others were below deck watching a movie when two large explosions rocked the ship. The lights went out, and the men scrambled for the ladders and hatches. Arriving at one hatch, Constantino and his shipmates could see flames topside; they then headed aft to try another hatch. After arriving on deck, Constantino could see the bridge burning, and he could hear the ammo exploding. An officer gave the order all seamen dread: "Abandon ship!" Constantino went over the side and was eventually picked up by a boat from the USS *Mt. McKinley*. They then aided in the rescue of others in the water. Although he was cold and wet, Constantino slept all night after arriving on the *Mt. McKinley*. The *Pinkney* had lost 36 men in the attack. Ironically, Constantino had been heading toward the engine room where he intended to write a letter when his friend badgered him into watching a movie. All hands in the engine room were killed.

The next morning, Constantino observed the stricken *Pinkney*. The Japanese plane was still wedged against the side of the ship. "I could even see the aircraft number—number 53," he recalled. It appeared to him that the kamikaze pilot knew just where to hit the vessel. Constantino thought that

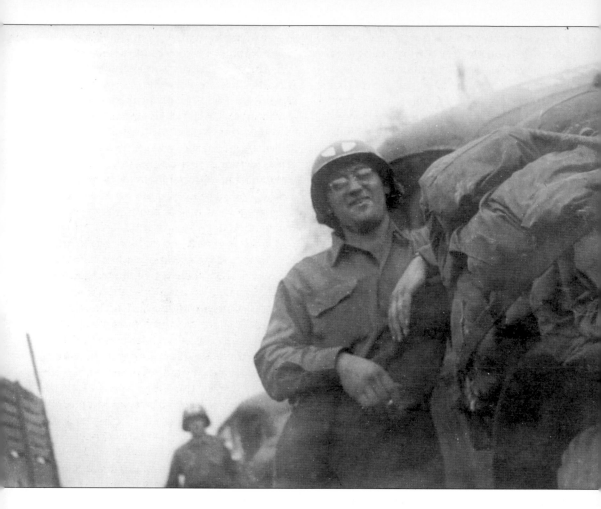

Jim Caruso, 314th Medical Battalion, 89th Infantry Division. "This was taken on the bank of the Rhine waiting to go across on landing barges. . . . It got a little hot around there a few minutes after this picture was taken." (Courtesy Jim Caruso.)

perhaps Japanese reconnaissance flights earlier in the week had brought back information to Japan regarding the fact that the *Pinkney* was remaining at anchor off Okinawa. Perhaps this facilitated the attack. It took the men two weeks to partially repair the ship, under Japanese air attack all the time.

Men remembered the numbing fatigue of extended combat operations. Dave Azzari, a rifleman in the 143rd Infantry Regiment of the 36th Infantry Division recalled the constant combat his unit was engaged in beginning from the invasion of Southern France. From August 1944 until the end of December 1944, Azzari and his unit experienced an incredible 134 consecutive days on the line—4 1/2 months of combat. Azzari remembered the mind-numbing, fatiguing routine: "Dig a foxhole every night, and keep going. . . . K rations for breakfast, K rations for lunch, K rations for dinner." On Christmas Eve, Azzari, a squad leader, led his exhausted squad into a farmhouse and ordered them to drop their packs they were about to get a rest. Suddenly, their platoon leader appeared and ordered them to get their packs back on—they were bound for the Battle of the Bulge as part of General George S. Patton's column trying to relieve the garrison at Bastogne. Azzari recalled vividly the ride north in open trucks, through snow, rain, and biting cold. They were back on the line for another 15 days before they received relief.

Al Conti was a combat medic with the 63rd Infantry Division serving in Europe. "I never wrote home to my parents telling them I was a combat medic," he remembered. "My letters always carried the message that I was the driver for the Catholic chaplain. My mother, being a devout Catholic, thought I was in good hands and out of danger's way." On April 3, 1945, Conti was wounded while attending to other wounded soldiers after they were caught in an open field by German machine gunners. Not wanting his mother to receive a telegram stating her son was wounded, Conti turned down the offer of a Purple Heart at the battalion aid station.

Jim Caruso was a combat medic with the 314th Medical Battalion, assigned to the 89th Infantry Division in the European Theater of Operations in 1945. He recalled: "My duties as a combat medic was to save as many men as I could, not how many I could kill. I would be lying to say that I was not scared, but that did not enter my thoughts once I was trying to help some poor guy that was shot up and dying." He described his general duties: "There was no standard procedure to reaching wounded men under fire. A medic was an infantryman without a gun. You went into battle the same as everyone else. As men were wounded, then your job changed to a combat medic. There were wounded men all around you, so the lack of work was not present. All that we had for protection was a Red Cross on our helmets and our infantry buddies around us. They took care of us very well. I was very lucky in that respect. [The Red Cross] did not help a lot of other medics. We lost quite a few good medics." Caruso stated, "The German soldiers did not honor the Red Cross all the time, because a lot of medics were shot through the helmet. I guess I was pretty lucky, because there were many times I was without cover treating wounded men and was not shot."

Al Conti agreed with Caruso. Conti said, "We faced the 17th SS Division, and I believe they used the Red Cross on my helmet as a target." As a medic, Conti was unarmed. He entered combat carrying two bags of medical supplies, a raincoat, and an entrenching tool for digging foxholes. He also carried a hunting knife for defense against nightly raids by German patrols looking for prisoners. Caruso also carried medical bags containing, to the best of his recollection, "bandages, tape, scissors, sulfur powder, ammonia sticks, tweezers, iodine, Band-Aids, and morphine 1/4 grain."

Bill Donofrio remembered coming under fire the first time during the Battle of the Bulge in December 1944. Donofrio's company was ordered to clear some 75 Germans out of a nearby woods.

It was afternoon as we started over snow-covered hills. After a couple hours, we suddenly heard firing ahead and to our left. We had stumbled on the Krauts at the edge of a town called Wingen. There was a lot of confusion as we had our first casualties. One sergeant [was] killed, and one of our platoon privates wounded. Medics worked on the latter as we heard on the radio, "Easy Company withdraw!" We made a litter for our guy and started back, but the icy hills made it tough going and we stopped. The rest of the company went on while we spent a cold and very scary night in the snow. We wore unlined field combat jackets and had no blankets. At the same time, we heard firing back in the town, saw tracers flying all over, and then the sound of [German] "screaming Meemies." Those were multi-barreled rocket launchers and made the damnedest scariest sound. We learned later that another of our regiments was involved and was badly beat up. This was our first real close contact with the Krauts.

Donofrio also recalled an episode that occurred when his company was advancing upon a small town in Germany, and his unit had to check the houses for enemy soldiers as they advanced.

While searching one house I heard a noise in a small lean-to shed. I kicked in the door and came face to face with a huge Kraut. I stumbled back, and as I went to fire, a scrawny chicken ran out between my legs. There was no Kraut, only my overactive imagination. I damned near had a heart attack! Believe it or not, even today after all these years, I can still see that Kraut, that damned chicken, and the shed.

Donofrio and his company continued their advance through increasing machine gun, rifle, and mortar fire. Donofrio described what happened next:

It got noisier, and then we were held up by what we thought was sniper fire. As we huddled behind an old farm house, we saw a number of what looked like GI bodies in an open field. They were GIs; we recognized the dark green combat jackets and pants

because they stood out so vividly in the white snow. Then we heard a voice from the field; one GI was calling to us. He yelled [that] he was wounded, and every time he tried to move he drew fire from the wooded ridge ahead and to our left. With Lt. Meshier's permission, I asked if he could make it with some help. When he said yes, I dropped my rifle and belt and took off. He was about 40 or 50 yards away, and when I bent over to help him up, he yelled, "No! The other side!" In the split second it took for me to move over, I heard what sounded like a swarm of angry bees, and saw snow kicking up around my feet. Then I felt a big bang in my right hand, and I dropped to the ground. I didn't move, nor did the other GI, as we instinctively played dead. The firing had stopped, and I sneaked a look at my hand. There was a big hole in the palm of my hand, and my middle finger was missing. It was bitter cold, and I recall asking the other guy if I could move closer to him. I was between him and the Krauts, and I think I really wanted to get as far away from them as I could—as if a few inches could make a difference. Meantime, the cold and snow did help in that I didn't bleed much. Lt. Meshier then yelled to us that the platoon would put covering fire on the ridge, and we should get back as fast as possible. They fired as we started to move, except I slipped and fell flat on my face. The other guy managed to stagger along while I scrambled up and ran back. When I fell, it scared hell out of me. While a medic worked on me, I breathed a huge sigh of relief. Another medic worked on the other guy. Suddenly, a shell exploded in the roof of the house we hid behind. Thank God for the stone walls; all we got was a shower of debris from the roof. A quick goodbye, and I was walking back to the battalion aid station, which was only a big shell hole in the woods. . . . A bunch of us boarded an ambulance, and the guy next to me nudged me, then pointed to his helmet. He said, "I think that's from your hand." I didn't recognize him as the guy I tried to help. Stuck on his helmet was

what appeared to be a piece of gristle or flesh. I think I said "Oh?" That was all either of us said.

After surgery in a field hospital, Donofrio was sent to the 236th General Hospital in Epinal, France, "where I spent two months after another surgery. I learned that I actually had been hit in the wrist with the bullet going down and through my hand. It broke bones in my wrist and hand before exiting." An officer pinned a Purple Heart on Donofrio's pajamas, for wounds received in action; "Sort of a proud moment, 'til the guy next to me had one pinned on him. He had a swollen knee he got while jumping into a foxhole." Donofrio paid tribute to the General Hospital staff, saying, "I can't say enough good things about their entire staff. That goes double for the field hospital staff. I remember them working for hours on end treating wounded as they kept pouring in."

Johnny Campisi served in combat with the 503rd Parachute Infantry Regiment in the Philippines. Once, his unit tried to flush some Japanese soldiers from a cave. They fired into the cave, which turned out to be an ammo dump. The resultant explosion was devastating. "You'd think the world was coming to an end," recalled Campisi. He was severely injured in both legs in the explosion and hospitalized on Noemfoor Island. Upon his release, he hitched a ride with an Air Force unit in an effort to return to his regiment. During a rest stop, Campisi watched a truck drive by. There, in the back of the passing truck, Campisi saw his brother Angelo. Campisi hollered for the driver to stop, and the two brothers had a joyous reunion. The joy was brief; Angelo's unit moved out a couple of days later.

Duties in combat varied. In 1943, Hal Cenedella, a newly commissioned ensign, reported for duty aboard the USS *Vestal*, a repair ship based in the Pacific. Cenedella was trained aboard ship to become a salvage diver. "Most of my job was taking bodies out of damaged ships," he recalled. "We put them in canvas bags underwater and then brought them up to load on the barges

"Winter fighting in Alsace Lorraine. That's three of the GIs from our Co. [Company L, 30th Infantry Regiment, 3rd Infantry Division] as we were taking a town. We wore those 'bedsheets' for winter camouflage. All the line vehicles were sprayed white also. The Germans also had white, so it was hard to tell one side from the other." (Courtesy Bill Dirienzo.)

overhead." The divers also performed limited repairs underwater, such as cutting the jagged edges off of torpedo-damaged hulls. Cenedella, who enjoyed this exacting duty, said his diving equipment, repair tools, and torches were all quite primitive.

Jim Vitton saw extensive combat with the 128th Infantry Regiment, 32nd Infantry Division on New Guinea and the Philippines. When Vitton arrived at Leyte, that island was supposedly under United States control. This didn't last long, however.

A few days after I arrived, the Japs sneaked in several boatloads of troops, and

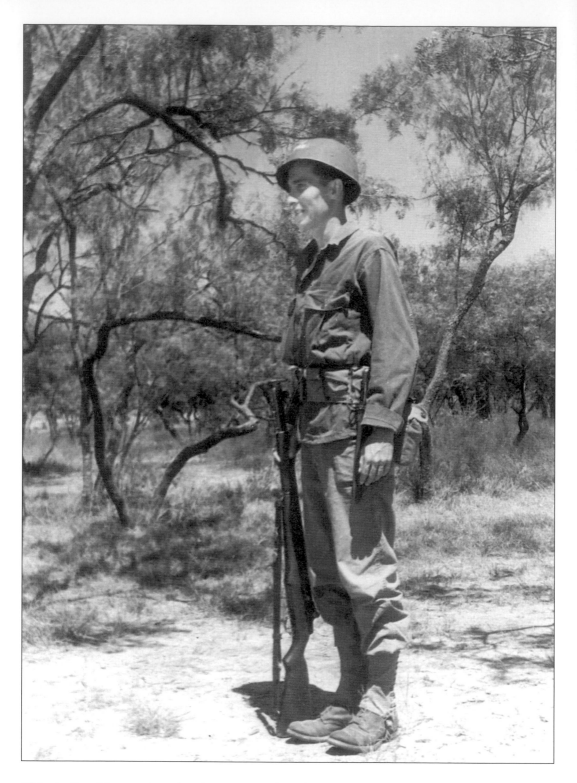

This is Jim Vitton, Assault Platoon, 128th Infantry Regiment, 32nd Infantry Division. (Courtesy Jim Vitton.)

the fighting began all over. It took some weeks thereafter to again secure the island. I was involved in several minor fire fights and occasional shelling, but nothing of major importance. Principally, we were assigned to patrol work, and most of the patrols were uneventful. At that point in time I still had not the slightest idea what war was all about. It was soon to change. One thing I did learn—it was necessary to dig your bed every night. Each night we were in a different area and had to dig another foxhole. One becomes pretty proficient with the little "pickmatic" [entrenching tool] you have strapped to your belt.

As a member of the Assault Platoon, Vitton was engaged in more than his share of combat. One of the more hazardous combat assignments was to participate in patrols. Vitton recalled:

I did a lot of patrol work, often behind enemy-controlled territory. We were classified at that time as a "nuisance patrol." Our mission was more or less to put a thorn in the side of the opposition. We ambushed their patrols that were trying to scout our positions, and after a fire fight we made a hasty exit. We set up road blocks and ambushed truck convoys. It was almost like playing hide and seek but obviously was not a game. I preferred that, however, to regular head-on combat, wherein you walked into the enemy fire and tried to dislodge him.

Vitton recalled how he was wounded in combat in the Philippines in 1945. It occurred when Japanese artillery bombarded Vitton's position. Aware that the Japanese occasionally sent their men into their own bombardments in the hope of achieving surprise, Vitton would peer out of his foxhole during lulls in the fire.

I raised up after the last shell hit. I got fooled. There was another shell that hit almost as soon as I raised up. There had been about a 45-second interval between bursts, but they threw another shell in about 10 seconds, almost as I raised up. The shell exploded on the slope side of the hole. About all I remember of that was that my eyes had closed but I could see, for a moment, through my eyelids, because of the brightness created by the explosion. Everything looked red. And then nothing. When I came to, I was paralyzed. I could move no part of my body. I finally could yell, and I did, for help. Someone in a nearby hole asked who I was. I told him. He said, "Come over into our hole," and I told him that I couldn't move. He then told me that they couldn't leave their hole to come and get me. There was still shelling going on. After a long period of time, I don't know how long because things were pretty hazy, I began to get some strength back into my arms. I still could not walk or crawl, but I finally managed to pull myself over to their hole by thrusting my elbows forward and

Domenick Porcaro as Commander of VFW Post 2307, Lynbrook, New York, 2001. (Courtesy Domenick Porcaro.)

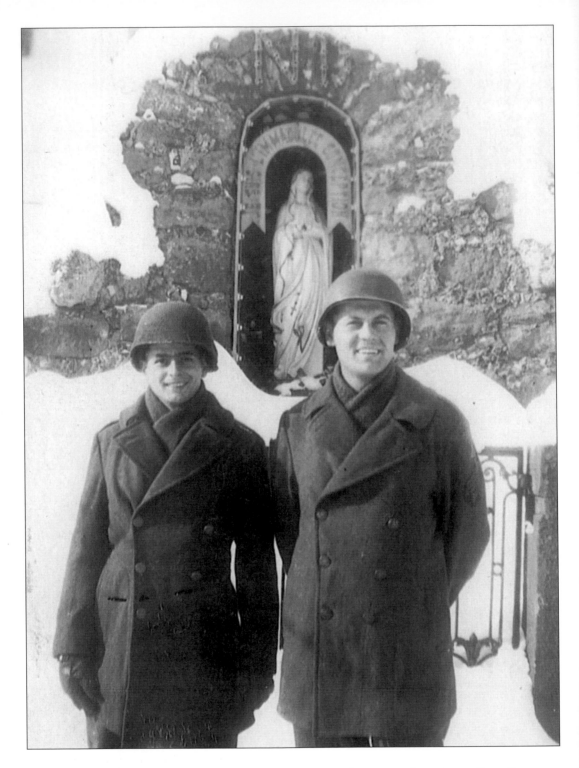

Paul DeCicco (left) and Forest (Skifoot) Johnson, 125th Armored Engineer Battalion, are pictured in a churchyard, Schweinheim, Germany. DeCicco attended mass in the beautiful church, and the unit used the tower as a look-out post. (Courtesy Paul DeCicco.)

then pulling the rest of my body along a few inches at a time. I remained there till daybreak.

Vitton was evacuated to a field hospital where he stayed for 10 or 12 days.

I didn't feel too bad, but I couldn't quit shaking. My whole body shook. It was almost impossible to eat. There is no pill or medicine for such a condition. Also, I had a very tiny hole about the size of a BB in my abdomen, in the area in front of the liver, maybe the result of fragmentation. There were other bruises also of no consequence.

When Vitton was released, he had to make his way back to his unit on his own. As he recalled:

No transportation was provided. I had to hitchhike back. As I left the hospital, a colonel drove by. He had his chauffeur stop and called me over. He said, "Soldier, where are your sidearms? Don't you know that the rules require you have your sidearms at all times?" I said, "Sir I have none. I just got out of the hospital, and I'm hitch-hiking back to my unit." "Oh," he said, "Carry on." So I did. It took three different trucks and finally a mile walk through the mountains to rejoin my unit. And when I got there, I no longer had a unit. There were only a few men left, so they had placed them individually in various other units.

Dean Belmonte, serving in the European Theater of Operations in the 292nd Engineer Combat Battalion, recalled his experiences during the rapidly moving combat toward the end of the war in Europe: "We built bridges, blew them up, then built them again." Most of Paul DeCicco's duties in combat involved demolitions of one kind or another. His first taste of combat came when he had to clear a German mine field in France. "I remember being scared, but it helped to be with buddies at the time, and there was no choice but to obey orders as they came down. It helped to be only 19 years old!" he recalled.

And it wasn't only front-line infantrymen who experienced harsh conditions. Al Miletta, the aircraft armorer with the 81st

Al Miletta, 81st Fighter Group, is pictured in Sicily on October 17, 1943. (Courtesy Al Miletta.)

Fighter Group who hit the beach as infantry in North Africa, remembered living in the field for three months. "Can you imagine four men in a hole with our pup tents over top. No showers; we washed out of a helmet. We weren't shaving either, until Gen. Patton took over our area and made us shave and line up for short arm [inspection]. We didn't see a female for six months [and] we had a good laugh over that." Miletta also recalled, "We were bombed nightly by German and Italian planes."

Since the P-39 Aircobras that Miletta worked on were ground-support fighter aircraft, they had to always be in close proximity to the battle area. This meant frequent moves for the unit, and Miletta moved an incredible 24 times in 30 months while his unit was engaged in combat operations. As Miletta recalled, "There was a

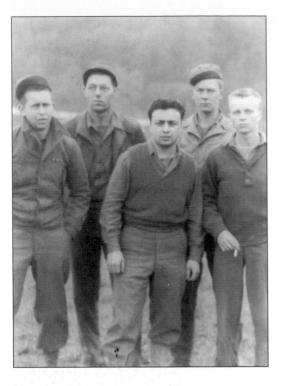

Lou Cerrone, 404th Fighter Group, is shown here third from the left at St. Trond, Belgium, October 1944. (Courtesy Lou Cerrone.)

time in North Africa that [German General Erwin] Rommel chased our troops behind us, and until the transportation trucks came to pick us up, there wasn't a soldier between us and the Nazis." The aircraft engaged in infantry support had to fly low to strafe the enemy. Miletta recalled an incident when "one of the pilots came back with chicken wire attached to the undercarriage of his plane he got down so close to the ground."

Miletta was also on guard duty at his base in Tunisia in 1943 when Italian Rangers raided the airfield and blew up some American planes. As Miletta remembered:

It was about midnight; I was on my way to the hanger to get a cup of coffee, and a plane behind me blew up—not one of ours, I believe it was a B-25. Right behind that was another; I ran to the garage attached to the hanger that was the fire station; I did my manual and hollered "Fire!" The fire dept. rolled out as did our men from the

barracks. *The airfield was surrounded and secured; all together three large planes blew up. None of our fighter planes were harmed. All the wheel wells were checked, but no more bombs were found. The next morning, the sailors captured the Italian Rangers. Something went wrong, and their escort didn't pick them up. In their interview they stated that they contemplated eliminating the guards, which would be easy for them to do as they were trained to do that. Imagine, it could have been a relative of mine.*

Ground crewmen in the USAAF bore a special responsibility, for upon their skill and diligence rested the safety of the pilots and air crewmembers who flew the airplanes they repaired and maintained. The mechanics and armorers knew this and took their responsibility seriously. They "sweated out" each mission and watched anxiously as aircraft began to return to base after a mission. Miletta remembered an incident when the pilot of the airplane he worked on went out on a strafing mission:

. . . and they were jumped by some German fighters; we lost five planes. Anyway, my plane came in, and then after I unstrapped him, he raked me over the coals because the guns didn't work and said he could have gotten killed. Wow, was I in for it. That was the one thing we all feared the most and here it happened to me. I commenced to open up the guns and trays and, wow, there was only one shell left in the guns. I called him back; he was a captain; I showed him what was left. He must have squeezed the triggers and froze; only he would know what he may have seen at that time to make him freeze.

Frank Carnaggio, another USAAF mechanic, recalled an air raid on their base at Florennes, Belgium, during the Battle of the Bulge. A German Ju-88 twin-engine bomber attacked the base. Rather than take cover, Carnaggio and others went out "to watch the war." Unfortunately, some USAAF pilots were killed during this raid. Carnaggio was assigned to the 48th Mobile Repair and

This is Frank Carnaggio, United States Army Air Forces, 1945. (Courtesy Frank Carnaggio.)

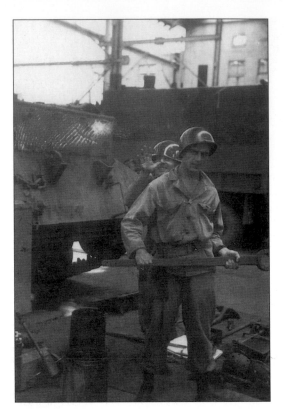

Mike Altamura (front) and John Puskarich are "hamming it up in Berlin—Krupp Works," 1945. (Courtesy Mike Altamura.)

Reclamation squadron (48th MR&R), which was attached to the 486th Service Group. The duty of the 48th MR&R was to travel to downed airplanes and attempt to repair them. For this task, the 48th was divided into eight crews. As Carnaggio recalled: "Each crew was composed of two airframe mechanics, an electrician, two sheet metal mechanics, a welder, a propeller specialist, a hydraulic specialist, a supply man, and a crew chief. The specialties didn't mean anything, though, because we all did what needed to be done when it needed to be done. We weren't unionized."

Each crew used:

. . . two 6X6 GMC trucks and a jeep. One of the trucks had a boom and winch on the front bumper. The boom was for lifting parts too heavy for us to pick up. (e.g., engines, propellers, wing sections, etc.) The winch was used with the boom, but could be (and several times was) used to winch the truck out of muddy fields. The boom truck was also our machine shop. We built a large tailgate (about 7X7) to use as a fairly sanitary "work bench." It was a job to raise and lower that tailgate. The other 6X6 was our supply truck—special tools, spare parts, hardware, fluids, etc. The jeep was our crew chief's personal vehicle, although we all could use it if we needed it. The crew chief was informed of downed aircraft. He led us (our two trucks) to the site where we would do what was necessary to either repair the airplane or salvage it. If the plane could not be repaired on the site (and it usually wasn't), or if it was 'surveyed' (written off), we would remove the wings, armament, and radios (all high-value items in those days), and call for a flat-bed trailer to take it away the remains.

Carnaggio worked mostly on P-38s, although the men occasionally encountered P-47s and P-61s. As Carnaggio recalled, "Being in an MR&R wasn't bad duty. We were like gypsies. We wandered all over our zone of operations and got to see a lot of the countryside that we wouldn't have been able to see if we had been assigned to just one airplane." When he wasn't wandering around the combat area, Carnaggio and company were busy at their assigned airfield performing whatever maintenance work was necessary: repairing engines, fixing flats, repairing combat damage, etc. "We did a lot of R&R, but that meant to us, 'remove and replace,' not 'Rest and Relaxation,'" Carnaggio remembered. "To tell the truth, we weren't really skilled enough to do much more than what we did."

Of course, even men engaged in the violent business of war could find interesting diversions and non-lethal uses of their talents. Shortly after his arrival in France, Frank Carnaggio became interested in motorcycles. He recalled, "We would explore battlefields in the course of performing our mission (doing our job) and would 'capture' abandoned German motorcycles, repair

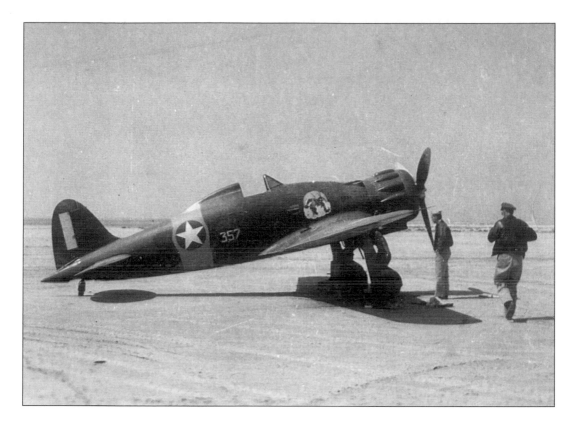

This is a captured Italian fighter, Macchi-200, in Borizzo, Sicily, December 1943. Note the USAAF markings painted on the aircraft. (Courtesy Mike Ingrisano.)

them, and ride them until the MPs caught us with them and confiscated them. Whereupon, we would return to a battlefield, 'capture' more machines, and ride them until caught again." On one such expedition, Carnaggio and a friend, Frank Baker, found a German motorcycle with a flat tire. Carnaggio remembered his friend's reaction as they tried to repair the flat tire: "We pulled the tube out to repair the puncture and found to our surprise that the tube was a ring of patches with patches on top of patches. Frank studied the tube for a few seconds, then looked at me and said, very seriously, 'We're not going to lose this war.'"

Mike Ingrisano remembered when a friend of his wanted to go for a different sort of joyride. At Borizzo Field, Sicily, there was a captured Italian fighter airplane, a Macchi 202. Ingrisano said:

One day one of my pilots, slightly in his cups, came by my tent, told me to get into the jeep, and we headed for the airfield. He wanted me to explain the mechanics [instrument panel] of the plane because, "I'm gonna fly that SOB." My knowledge of technical Italian was as bad as my Neapolitan-Brooklyn Italianese. Fortunately, when I pointed out to Bobby that the plane's rear tire was flat, I succeeded in discouraging that little feat.

Jim Vitton, while serving in the Philippines, received a letter from his sister informing him that a family friend was in a nearby village, stationed with an engineer unit. Vitton borrowed a jeep and, with another friend, set out to visit the man. This should have been a straightforward trip but, according to Vitton, there was a problem.

A lot of Filipino towns have very similar names. There was BagaBag, Bayombong, BangaBang, etc. Several miles from town

we came to a river. Rivers there often have no banks. In the dry season they are small. In the wet season, they become very wide and spread out over a lot of the land. In many areas there are no bridges, and the roads become impassable. In this case there was a bridge—a very long one. As we were about halfway across the bridge, an enemy Nambu, heavy, .30 caliber machine gun opened up on us. To take the time to turn around probably would have been fatal, as we would have been pretty much a sitting target, so I speeded up to get to the far side, which still posed problems as that was where the machine gun was. As we got to the far side, however, there was a high embankment on both sides of the road that for the moment protected us from the weapon. Obviously, we could not proceed forward as it appeared we had blundered into enemy-held territory, so the only option was to go back across the bridge. I turned the jeep around, revved up the motor, and away we went. Bullets banged all over the bridge as we made our way back, but we made it OK. Never even scratched the jeep. When we got back to our perimeter, I checked a map that we had. I had confused the town names due to the similarity. My buddy, whose name I've forgotten said, "I ain't going for any jeep rides with you no more." I could understand that.

Sam Mastrogiacomo's first two missions as a B-24 tailgunner were, in his opinion, "milk runs." In USAAF parlance, this meant the missions were fairly easy with no serious enemy action. On his first mission, December 13 and 14, 1943, Mastrogiacomo was gung-ho and ready, but he saw only a few German fighters in the distance, attacking another U.S. bomber formation. On his second mission, he asked his navigator, "Are the Germans afraid to attack us? I wish they would; I'll shoot them out of the sky!" To which his navigator wisely answered, "You better hope you don't see them." Mastrogiacomo would have his chance in the horrors of aerial combat soon enough.

On February 24, 1944, Mastrogiacomo's group was scheduled to bomb aircraft factories at Gotha, Germany. The group sent out 25 planes, but only 13 made it back. Mastrogiacomo's aircraft was attacked and took many hits; his tail turret system was damaged, and the Plexiglas window was shattered. Mastrogiacomo heard the navigator call out another German fighter attack, but he couldn't see out the shattered Plexiglas. Desperate, he removed the screws holding the window and pushed it out—now he had an open view. The tail turret, however, wouldn't turn because the hydraulics were shot out. With his crew's lives on the line, Mastrogiacomo reverted to emergency manual control over the turret. Despite this precarious method, he managed to shoot down two enemy fighters, with a third probably destroyed. He and his fellow airmen were engaged in the longest aerial battle to date, two hours and twenty-five minutes. Mastrogiacomo's airplane was one of the 13 to make it back to base. The 445th Bombardment Group received the Presidential Unit Citation for this action.

The next day, he was ordered to report to the group's public relations office. News of his heroic efforts during the raid had gotten out, and the group wanted the press to do a story on him. "They took my picture, but then someone saw Jimmy Stewart outside. They dropped me and all ran to Stewart," he recalled. So much for his fleeting fame. But worse was yet in store for Mastrogiacomo.

Before dawn on April 9, 1944, Easter Sunday, Mastrogiacomo was roused from his slumber for a mission. "I had wanted to go to church that day," he remembered, "and now we had to fly a mission." It was so foggy that the crew had to use flashlights to find their airplane. The crews received word that the mission had been scrubbed, followed by an update saying that the mission was back on again. The men waited anxiously while they received final instructions, and soon Mastrogiacomo took off on his 13th and last mission.

The flight was extremely hazardous in the thick fog; two aircraft collided as they

maneuvered to join into formation for the flight. The target was a factory, which made parts for German long-range rockets. As the formation headed over water en route to Germany, they received an abort call from headquarters. Unfortunately, not all planes received the recall, and 35 bombers, without escorts, reached the target. "The Germans looked for days like that," recalled Mastrogiacomo, whose plane continued on to the target. The fighters attacked Mastrogiacomo's aircraft and "shot it up pretty bad." They dropped their bombs on a target of opportunity, a rail yard, and attempted to evade the attacking fighters. But, being damaged, they couldn't keep up with the rest of the small formation, and they trailed behind. They had one engine out and another spouting oil as they descended low over the sea to avoid German fighters. The navigator said they were about 100 miles from Sweden. The unanimous cry from the crew was quick in coming: "Let's go to Sweden!"

As the stricken aircraft made for Sweden, Mastrogiacomo saw three dots in the sky behind them, getting bigger as they approached. He fired a couple of bursts from his tail gun, "just to let them know I was awake." As the German fighters closed on the American bomber, Mastrogiacomo opened fire. "I got one of them—he went straight down into the sea, pieces of his cowling coming off," he said. The other fighters left as the bomber crew began to jettison everything not nailed down in order to lighten their weight. They were intercepted by a Swedish fighter plane, which showed them where to land.

The bomber landed with two engines out and their landing gear shot up. They were greeted by machine gun-toting Swedish guards who said, "Welcome to Sweden." Thus began six months of confinement in Swedish prisons. Mastrogiacomo and crew were first in a camp which also housed some German soldiers. The Americans had to march past the German barracks on the way to their mess hall, and the Germans would taunt the Americans, calling them pigs and American gangsters. On the third day, Mastrogiacomo convinced his fellow detainees to charge the Germans when they taunted them. "I'm an instigator," he confessed. The inevitable happened—the Germans yelled and the Americans charged. "There were eight of us and about 15 Germans, and we beat the hell out of them," recalled Mastrogiacomo proudly. The Swedish guards eventually broke up the fracas and moved the Americans to another camp.

The new detention base housed Americans, Canadians, British, Poles, and Frenchmen, about 25 to 30 flyers. As more men came in, the Americans were moved yet again to a more remote base. From there, an escape, with the tacit help of the Swedes, was planned. The men were able to commandeer a B-24 and fly it to a base in

Mike Altamura's half-track, Skunk Hollow, 750th Tank Battalion, is shown here. (Courtesy Mike Altamura.)

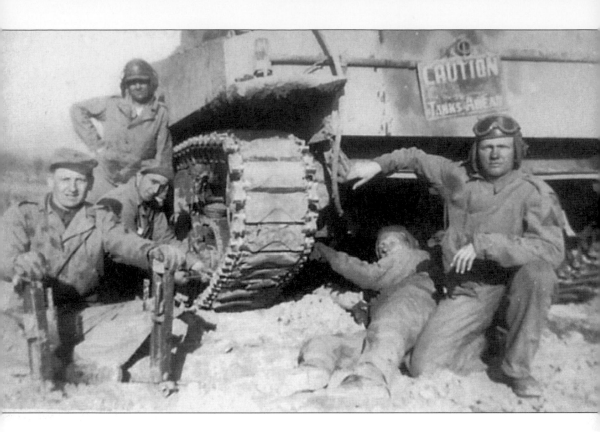

"Tank crew repairing tank tracks." (Courtesy Mike Altamura.)

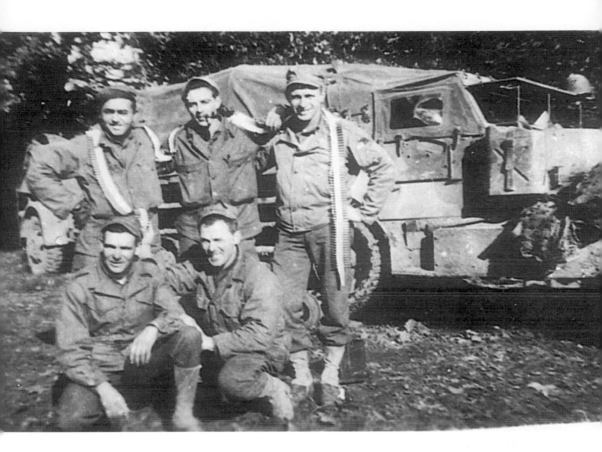

Men of the Service Company, 750th Tank Battalion, are shown here. From left to right are: (front) Henry Jones and John Puskarich; (back) John Gunderson, Mike Altamura, and Eddie Oryll. This image was taken in France on October 18, 1944. This was the last picture taken of Oryll before he was killed in action. (Courtesy Mike Altamura.)

France. Following a meal of "fresh eggs, home fries, and bacon," the men were flown to Scotland. Since they were escaped POWs, they could no longer fly combat missions; had they been shot down and recaptured, the Germans could have shot them as spies or war criminals. Thus, Mastrogiacomo and the others flew back to the United States.

After his return to the States, Mastrogiacomo was given 30 days off, and he stayed in hotels in Miami before reporting for duty at Fort Myers, Florida. He spent two weeks as a military policeman, which he didn't like, and then was reassigned as an aerial gunnery instructor. He served in this capacity, passing on the knowledge he had gained during 13 combat missions with three confirmed kills, until his discharge in Columbus, Ohio, at the end of August 1945.

The U.S. Army's emphasis on mechanization and mobility during World War II reflected itself in the myriad types of units and the duties men performed in those units.

Salvatore "Tootie" DeBenedetto is pictured here. (Courtesy Tootie DeBenedetto.)

Mike Altamura was the battalion armorer in the Service Company of the 750th Tank Battalion. One of 30 men in the company, all NCOs, his duties included riding with a partner in a half-track in support of his battalion's tanks. The half-track was loaded with spare parts and tools and was armed with a .50 caliber machine gun. The armorers would ride with the battalion tanks and fix them as they broke down. Often they would have to send tanks back to Ordnance repair units for major repairs. The men would sometimes accompany large tank-retrievers as they journeyed between the lines to fix tanks abandoned during battle. One of Altamura's duties was to inspect such tanks for booby traps; if he found anything suspicious, such as trip wire, he would call for demolitions, and the tank would be blown up on the spot. "It was the better part of valor," he recalled. He was very proud of the fact that his unit left fewer tanks on the battlefield than any other unit—testimony to the efforts of the battalion maintenance personnel. Altamura paid a tribute to the foot-soldiers he and his tanks supported; "I had it easy—I rode in half tracks. I watched the guys slogging through the mud, snow, and slush. They were great; they deserved everything they got."

Like other men, Altamura also suffered many close calls during the war. His half-track was crossing a river under a smokescreen when German airplanes attacked, dropping bombs. Altamura and his friend, Sgt. Eddie Oryll, watched as an airplane made two passes. "I saw something drop from the airplane; it was a spinning device discharging bombs as it fell," he remembered. Sgt. Oryll pushed Altamura down just as the bombs exploded. Altamura got to his feet and saw that Sgt. Oryll was badly wounded; he gave his friend first aid, but the man soon died. Another time, Altamura and his comrades were driving their half-track on a supply replenishment mission when they suddenly came upon a group of German soldiers. Altamura opened fire with the mounted .50 caliber machine gun killing all the Germans. The Americans checked their map and found they had taken a wrong turn

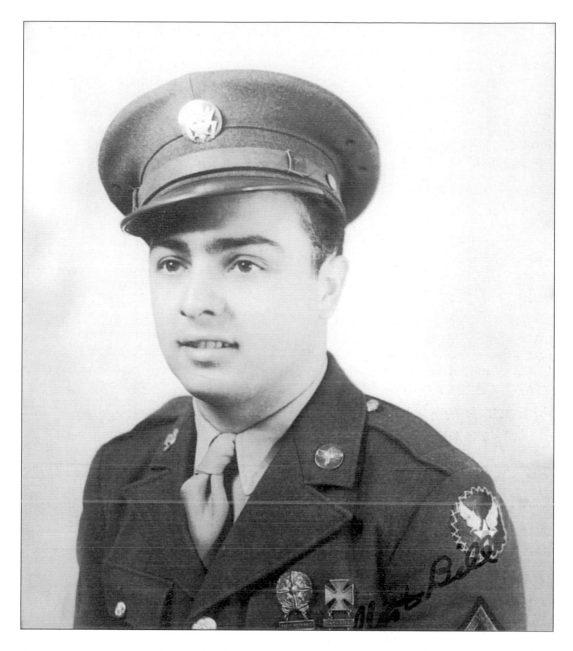

Lou Cerrone is shown here after his graduation from Radio School, 1943. (Courtesy Lou Cerrone.)

Lou Cerrone is digging a foxhole in Normandy, July 1944. (Courtesy Lou Cerrone.)

and were in German territory. Quickly, the men turned around and retraced their route back to American lines.

Tootie DeBenedetto, because of his experience as a mechanic and driver, was detached to serve as a truck driver on the Red Ball Express, delivering food, ammo, and fuel to General George S. Patton's tanks during their drive to Germany in 1944. Red Ball Express was the code name for the operation bringing supplies from ports in northern France to front line units using 6,000 Army trucks and trailers. DeBenedetto, who was a driver for his divisional commander, Major General Kramer, at the time, volunteered for the hazardous duty. He recalled:

There were very few whites in that outfit [most of the drivers were African Americans]. . . . It was very dangerous driving with hundreds of cans wet with gas and ammo going through the towns totally engulfed in flame. We had to have eyes in the back of our heads. The headlights on the trucks were like little cat eyes [these were blackout headlights, allowing only a small slit of light to shine through]. We were being shot at going through town. . . . There were big problems with the trucks breaking down along the side of the road. Drivers stripping gears in the trucks, because most never drove before. I found myself stopping and getting them back on the road dodging gun fire while working on the trucks—that was not an easy job, but I was young and fearless. That was not my job but I stopped. We had snipers all around us, planes overhead. We were dodging everything. The drivers were very tired sleeping at the wheel, going off the road. Many times we had to get out of the trucks and fight, then fight our way back to the truck, many battles were fought on the way to Patton. . . . I can tell you that we whites and blacks worked very well together; we got the job done; Patton was very pleased. I'm proud and honored to have served in the Red Ball Express for Gen. G. Patton.*

In addition to mechanization, the American forces were characterized by their use of technology in warfare. Radios became an important part of operations. C.J. Lancellotti arrived at Utah Beach, Normandy, with his unit, the 137th Signal Radio Intelligence Company, on September 3, 1944. The unit supported the U.S. Ninth Army "with the mission of intercepting enemy radio transmissions, locating transmission sites with the use of direction finders, decoding and analyzing messages, and attempting to identify transmitting units." Lou Cerrone, a radio operator assigned to the 404th Fighter Group in England, worked in a "homing station to assist pilots who were lost and needed help to get back to their bases." As Cerrone proudly recalled, "In the period before D-Day, our homing station saved several pilots who had to ditch their planes in the English Channel."

Even those men who normally worked in rear areas, such as radio technicians, were subject to danger from the enemy. Lou

This is Ralph Barrale, 821st Military Police Company, in Arlon, Belgium, December 1944. (Courtesy Ralph Barrale.)

Al Panebianco is shown in Anzio, Italy, 1944. (Courtesy Al Panebianco.)

Cerrone, whose fighter group was one of the first to operate from a field in Normandy after the invasion, recalled, "We were attacked several times by the German air force while in Normandy and lost several planes and about 40 men." As already noted, Frank Carnaggio and Al Miletta, both Air Forces support men, were subject to similar attacks. Tony Lima, a Marine on Iwo Jima, remembered when more than 220 Japanese soldiers infiltrated a nearby Air Forces unit tent area and killed 44 men and wounded 88. Lima's Pioneer Battalion was able to overwhelm the invaders and stop the attacks.

Military policemen were also caught in tight situations. Ralph Barrale, a military policeman with the 821st Military Police Company, recalled his unit's entrance into Arlon, Belgium:

There was only a squad of engineers protecting the town. Boy were they happy to see us, even if we were only MPs, because we were a company of GIs. Well, we relieved them, and we took over the town and put guards out in a 10-mile radius around the town, MPs posted on all the roads. I was a jeep driver and with a non-com we would make our rounds, check and relieve all the guards with other MPs. We were strafed and bombed by the Germans throughout our stay in Arlon.

Barrale described one such attack that occurred while he was driving a jeep full of MPs:

A German plane was bombing and strafing the town as we were coming in from the other end, and I saw him turning to get a shot at us; well, I told the guys—hey he's coming after us—so I stopped the jeep, and we ran into a stone barn. I looked up, there was no roof; the plane went by strafing and dropped another bomb. I know I was raised 2 feet in the air from the concussion. Well, we got a few shots at him, but what good is a carbine against a plane?

In combat, men's lives depended on the "tools" they used. It is not surprising, then, that they expressed strong opinions about those tools. Dave Azzari recalled that, even as a staff sergeant, he carried a Browning Automatic Rifle (BAR), which he called "awesome." He also felt that the M1 rifle was a "hell of a piece of equipment." Jim Vitton, a rifleman in the 32nd Infantry Division in the Pacific, recalled that "In our unit, with the exception of a certain few weapons, depending on the mission, you were permitted to carry any weapon that you were comfortable with. I generally preferred the carbine to the M1, as I have small hands and it was an easier weapon for me to handle. The .45 [pistol] was an add-on as I believed it made a better close-in weapon." Sam Lombardo, an infantry officer in Europe, also preferred the carbine, due to its lighter weight, even though he liked the M1 and had set a marksmanship record during training at Camp Fannin, Texas.

Pete Buongiorno agreed with the

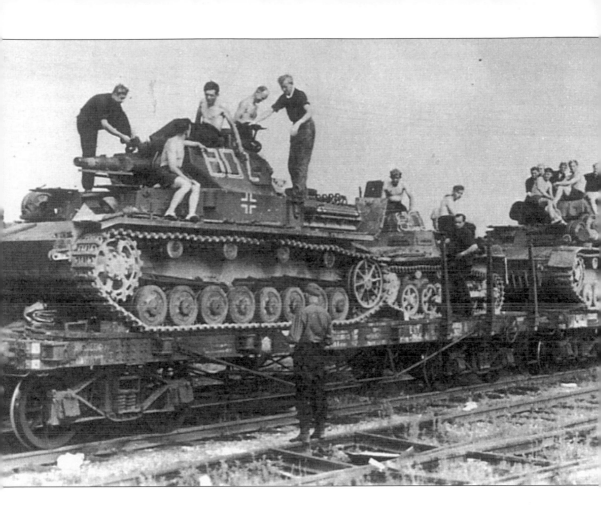

"Captured German picture. Probably 1943, moving tanks by rail to France." (Courtesy Mike Altamura.)

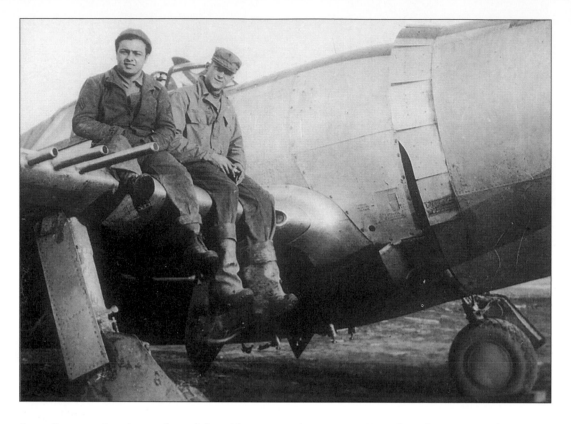

Lou Cerrone is pictured at left with Doug White at St. Trond, Belgium, October 1944. (Courtesy Lou Cerrone.)

assessment of the M1 rifle. He recalled, "You are trained to use all the infantry weapons in basic training, but you specialized in only one. In my case it was the M1 rifle. I personally believe that this weapon was one of the best made for the infantrymen." Buongiorno remembered how effective the M1 could be in combat. "I just loved that rifle because you [could] fire eight shells as fast as you pulled the trigger, and it was all automatic. If it got wet or a little dirty, it still worked. If you had 10 guys all firing at the same time at a target, you really fired a lot of bullets in a few minutes."

Paratrooper Tony Pilutti favored the carbine with a folding stock. He modified the standard rifle sling, using two slings together, which made the weapon much easier to carry and made it "very handy to use on patrol, since it would be at the ready." Pilutti also used a Gammon Grenade, which was

popular with paratroopers. This was a concussion grenade that consisted of a sock or bag-like casing the size of a large softball, filled with explosives and set with a fuse. Although the grenade was to be handled with extreme care, Pilutti remembered using one as a pillow. "It was softer than my helmet," he recalled. Once, Pilutti and another man threw a Gammon Grenade into the open hatch of a German tank. "There was a man standing in the hatch, and he ducked in and closed the hatch. The results were terrible," he recalled. Pilutti recalled that there were men in each company who were trained explosives experts. "The rest of us knew just enough to be dangerous to ourselves," he said.

Al Panebianco, an infantryman in the 157th Infantry Regiment, 45th Infantry Division, in the European Theater, also had his preferences. "As most people know, our

weapons were inferior as compared to German weapons. My favorite weapon was the M1 Garand rifle. Although I had the choice of carrying a .45 Colt revolver or a carbine rifle, I chose the M1. It was heavier, but I felt more secure, and it was a much better weapon," he recalled. As a member of a heavy weapons platoon, Panebianco also used the 60 mm. mortar and the bazooka. According to Panebianco:

The 60 mm. mortar was a great weapon. It saved the men in our company many times. I can recall one night, our men were pinned down on a steep hill right in front of us, we fired so many shells the tube of the mortar turned "white hot," but we saved the day. Of course, the tube had to be replaced. I was concerned on that particular night, because the mortar tube was nearly in an upright position, and I thought of the possibility of the shells wounding our own men and even coming down on us. It was one of those good nights when everything went well.

Commenting on the bazooka, Panebianco said:

The bazooka, in my opinion, was not the best weapon. It could not penetrate the armor of a German tank. It was effective in disabling a German tank by blowing its track. However, the tank was not destroyed and could be back in use after its track was replaced. The bazooka man had to be very close to the tank before taking his shot to disable the tank from functioning.

John Mangione, a gunner with the 1st Field Artillery Battalion in the Pacific Theater, praised his unit's 105 mm. howitzers. "They were fabulous," he recalled, "flexible, quick, and, depending on the crew, quite accurate." The guns fired armor piercing, high explosive, and fuse shells. Mangione had less praise for the sidearms he used. "The carbine was very inaccurate, and you had to be right on top of the target to hit anything with the .45 pistol," he said. Mangione actually had cause to use the sidearms on at least two occasions when his gun position was being overrun by the Japanese in New Guinea and

the Philippines.

Some men felt the superiority of German weaponry. Pete Buongiorno, an infantryman in Europe, said, "I believe the Germans machine guns and mortars were better than ours, and the German 88 artillery gun was a weapon that could be used on tanks, planes, or personnel and very deadly. Their tanks were much better than ours until near the end of the war, when America came out with their new tanks." He also recalled being attacked by a German jet fighter airplane: "We were also shelled by a German jet plane that had come out near the war's end. I remember hearing the bomb coming down before we heard the plane; usually it is the other way around. As the plane left, we heard the noise of the jet engine." Despite Germany's perceived and real advantage in weaponry, Buongiorno conceded that "when it came down to the M1, we had the best weapon."

In comparing various aspects of U.S. and German weapons, Al Panebianco recalled that "Our air cooled light machine gun sounded like it was firing in slow motion in comparison to the rapid fire of the German machine gun. In summation, I would say we were outclassed by Germany's weapons and armor." Both Panebianco and Buongiorno reflected that Germany had had more time to develop and produce weapons, and this probably led to their relative superiority to U.S. weapons.

Aircrews and groundcrews alike remembered their airplanes with fondness. Al Miletta, an armorer working on P-39 Aircobras, said the sleek P-39 "was a fine airplane for its time. . . [it was] excellent for strafing and [was] a help to the infantry." Dom Porcaro was a Navy airplane engine repairman in the Pacific Theater. He worked on Navy standard "Pratt & Whitney 18-cylinder radial engines, 1,800 HP at 3,000 RPM, dual ignition system." As Porcaro recalled, "We were well equipped to do a first class job. Our engines came out good as new." Art Pivirotto, who flew anti-submarine patrols in Navy B-24s, recalled that they had "fine

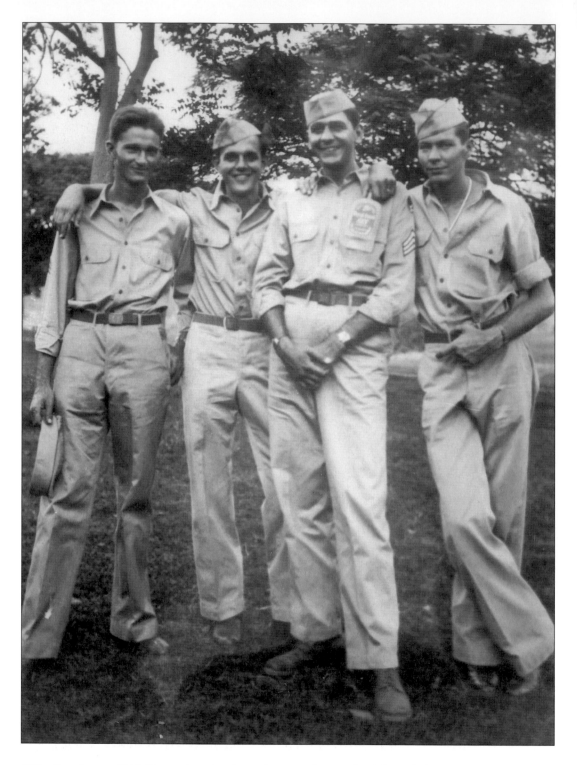

Mike Ingrisano, 37th Troop Carrier Squadron, is shown third from left in Ismalia, Egypt, on October 10, 1943. (Courtesy Mike Ingrisano.)

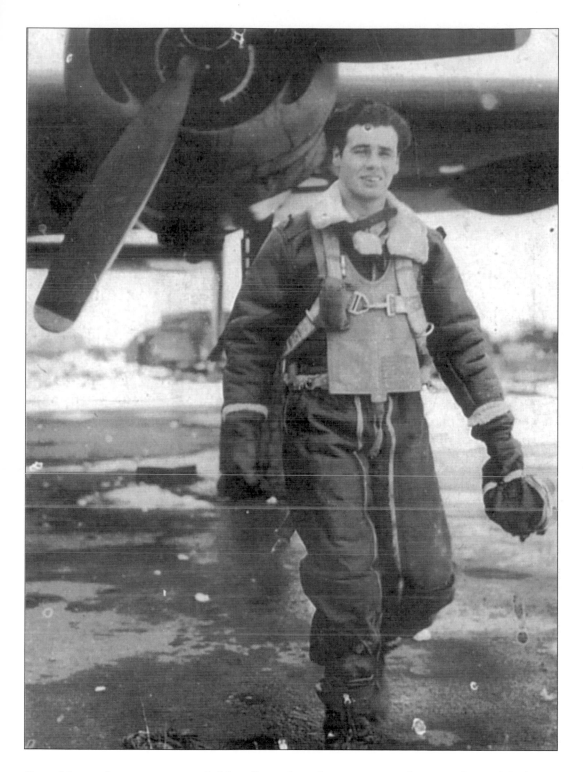

Sam Mastrogiacomo was a B-24 tail- and waist-gunner in the 702nd Bombardment Squadron based in England. Mastrogiacomo wears the typical flight clothing for crews of high altitude bombers. (Courtesy Sam Mastrogiacomo.)

equipment, excellent pilots, and great crews." In particular, their radar was very good, able to pick up surfacing enemy subs. Mike Ingrisano, a radio operator aboard C-47 troop carriers, paid tribute to the airplane and the crews that flew it:

Best damn [aircraft] that ever flew, and the kids that flew them, the best damn pilots. My skipper for most of the missions was a 19-year-old; our co-pilot was 20; crew chief 21, and I was the old man at 23. After combat, the tales about the C-47 are almost mythical, except that [they] were true. She would fly on one engine, stand over a hundred hits, anywhere, except in the para-packs containing high explosives, and she had a glide ratio of some 1 mile height to 1 mile glide. And she could float before heading to Neptune's grave. No self-sealing gas tanks, and no armor plating. At 700 feet [altitude], we were nice targets, and at 120 MPH or less when we dropped troopers. I'm still here.

Vince Guzzardi was a P-47 fighter pilot with the 53rd Fighter Squadron. "Regarding the aircraft we flew, I would not have traded it for any other," he said. "It was a flying tank and could take all kinds of punishment and still get you back." Guzzardi flew 44 combat missions during the war.

The physical hazards of flying combat missions were not restricted to enemy action. Flying at high altitude in unpressurized, unheated airplanes, the combat aircrews were exposed to deadly conditions during their entire flight. Sam Mastrogiacomo, a waist- and tail-gunner on B-24s, recalled that the "first couple of missions I was on we just had the fur-lined coats and boots, and it still got pretty cold. Forty below zero. It was a Godsend that the heated suit was invented. Everything was heated but the helmet. Once in a while there would be a short in part of the suit. We discovered by using a safety pin, you could complete the circuit." The B-24s flew with the waist-gun windows open, exposing the men to extremely cold air and the danger of hypoxia, a lack of oxygen reaching the tissues. Airmen struggled even with oxygen masks at altitude, as Mastrogiacomo recalled: "Our oxygen mask

would block up with ice at high altitude. It seemed like every half hour you would have to unbuckle your mask and break the ice out of it so you could breathe." Mastrogiacomo also commented on the general discomfort experienced by the bomber crews: "About the sixth mission, in January of 1944, they issued us flak suits. They were so doggoned heavy that we would stand on them or sit on them. We had enough weight on our persons with a Mae West parachute harness, fleece-lined uniform, boots, oxygen mask, goggles, wires for the throat mike, and earphones. That was about all the weight we could muster, and then some."

Al Panebianco commented upon some of the infantryman's clothing. While serving in Italy, the men wore regular field jackets. However:

There was a period of time we were issued shoe pacs and parkas. For the combat infantryman, neither issue was satisfactory. The shoe pacs came with liners, which would slide back, and our feet would bleed at the bottom of our toes. The parkas came with sheepskin liners. They were very warm and burdensome. One advantage is that they were reversible. One side was snow white and was good camouflage when fighting in the snow. Most of us discarded these items. For rear echelon personnel, these GI items were great and appreciated. We went back to wearing our old reliable combat boots and fatigue jackets.

Near and dear to every soldier's heart was food. The Army developed various types of field rations for the soldiers, and men's opinions of them varied. Dave Azzari, an infantryman in Europe, told of how he prepared the K ration. The K ration came in a wax-coated box and contained such items as hash, crackers, a bar of chocolate, and cigarettes. Azzari would punch holes in the wax box with a bayonet. Then he'd fill up a canteen cup with water and soak the chocolate bar in the water. Finally, he'd set the wax box on fire; it would burn slowly, and Azzari would heat the chocolate mixture over the flame to make passable hot

chocolate. Al Conti, a combat medic, thought most of the rations were adequate. Whenever the unit's kitchen could bring up a hot meal, "it would be just like Christmas," he recalled. Gill Fox remembered that the staff of *Stars and Stripes*, in Nancy, France, were catered to by a GI who had been a professional chef. "That man would take that junk [GI rations], and you had a meal you wouldn't believe," he remembered. Traditionally, Navy food aboard ship was superior to that of the other services. Hal Cenedella, serving aboard the USS *Vestal*, said, "Everybody in the Navy got served well compared to the other people."

Frank Carnaggio, serving in Europe with the Army Air Forces, provided his recollections of K rations:

K-rations, in case you are not familiar with them, were emergency rations in a box very closely proportional to the old Cracker-Jacks boxes. K-rations came in breakfast, lunch, and dinner "flavors." Each box contained crackers (we called them dog biscuits), a small can of processed American cheese, or chopped beef and carrots, or scrambled eggs. Also included were a four-pack of cigarettes. . . (Chelsea, Wings, and others) toilet tissue, dehydrated coffee, and soup packets—well, you wouldn't believe what they could package up in the box. There was also included a small pack of sweets. . . . There was a technique to opening a box of K-rations. Remove the outer cover. The inner box was covered with an impermeable coating of something like wax. One made an incision across the center of the inner box and broke it open across one's knee. In supper rations you could open a small can (about 3 inches in diameter and 1.5 inches in height) of chopped pork and carrots, sprinkle the soup mix over the meat, and fry the meat it in your mess kit. It was delicious. But as I write these words, I ask myself today, compared to what?

Carnaggio also elaborated on other types of rations available:

We also had 10-in-one rations. They were good! The contained cans of fried eggs, bacon (raw), coffee, sugar, and other goodies—to tell the truth, I don't remember, but they were banquets compared to K-rations. We also were issued D-rations. They were hard, tasteless chocolate bars that no one liked, but that was the idea. You wouldn't eat them unless you were very hungry. Fortunately for me, I never felt the need to develop a taste for D-rations. . . . C-rations consisted of two cans about the size of a Campbell's soup can. One held "dog biscuits," coffee, and other things that I no longer remember; the other can contained meats or beans—something already cooked that could be eaten cold or heated and eaten.

Summing up his experiences with Army

Armand Castelli is shown on Suicide Cliff, Okinawa, 1945. Japanese soldiers committed suicide by the hundreds by jumping from this cliff rather than face capture by the Americans. (Courtesy Armand Castelli.)

rations, Carnaggio said, "They weren't what one would call gustatory delights. They sufficed to keep the hunger pangs under control, but that was about their limit."

Before Carnaggio moved to the continent, he was stationed in England and presumably had the benefit of eating at fairly normal mess halls. He recalled:

In England the food was acceptable—although at times, just barely. When I first entered the Army, I wouldn't eat SOS because of the name, but later, in England, learned that it was really very good. A typical breakfast in a mess hall in England would consist of SOS, oatmeal, coffee (with canned milk), dried eggs (okay if you ate them freshly scrambled—before they began turning green) toast, (ugly but tasty English brown bread), and oleo. We didn't go hungry.

John Mangione, serving in New Guinea and the Philippines, experienced other types of rations. Since supply lines to Australia were much shorter than those to the U.S., Mangione's unit received Australian rations. For a whole year, Mangione ate only three different meals: tins of beef and gravy, pork and gravy, and something they called "donkey meat." "It was absolutely horrible," he recalled. "It was the worst food I ever ate in my life." He preferred K rations on those rare occasions he could get them. Of course, this would all be held in perspective. Bill Donofrio remembered when he had gone two days without sleep or hot food during the Battle of the Bulge in December 1944. Lying in the snow (the ground was too frozen to dig in), the men were miserable. Donofrio recalled:

The only bright spot came from our mess sergeant. I'll never know how he did it, but there he and his crew were, in the middle of the night, with hot food. We didn't have our mess kits with us, so we used our canteen cups. Using fingers as forks and spoons, we had stew, then fruit salad, then hot coffee. No joking, that was an unforgettable meal.

Al Miletta, an aircraft armorer who landed in North Africa under fire and eventually made his way through Sicily, Italy, and India to China, had the unusual opportunity to experience rations in each theater. Remembering the food in China, he said, "the food wasn't too bad [but] the buffalo meat had a bad smell. The water was terrible; we got our water out of rice paddies; the buffalo were chased out of the paddy, and the water was collected and boiled, then pills were added to it and it was put in a rubber Lister bag for us to drink. I still can't drink water to this day, we have good well water here and I still can't drink it."

The end of the war brought no immediate improvement in the men's diet. Armand Castelli, serving in the 176th Finance Section in the Army of Occupation in Okinawa in 1945, recalled an instance "when we got

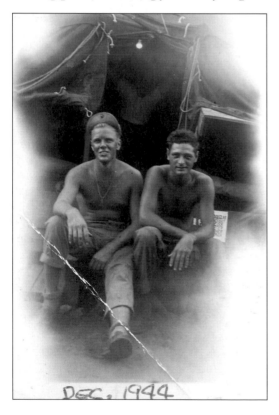

DEC. 1944

Tony Lima, 5th Pioneer Battalion, 5th Marine Division, is shown at right with a friend. "This was taken after we got back to Hawaii after Iwo Jima." (Courtesy Tony Lima.)

fresh eggs after almost two years of powdered eggs, mashed potatoes, and milk." The eggs were delivered "in the early morning and instead of being refrigerated, they sat in the hot sun. The next morning they were served for breakfast, the smell was sickening, some of the idiots ate them, and most of us took them and dumped them in the garbage can." Although the mess officer threatened court-martial for waste of food, the men avoided this by asking whether the officers' mess had been served rotten eggs. Patrick Molinari stated that, after the end of the war in Europe, the men were able to eat more hot meals. Further, he was able to supplement his bland Army diet by engaging in a boar hunt with friends and local German civilians.

The men easily recalled the horrors of war. Pete Buongiorno recalled being under fire for the first time during a fifteen-minute artillery barrage while assigned to the 30th Infantry Regiment, 3rd Infantry Division. It was "very scary, but what hit you is hearing the guys that got hit calling for help, it really is depressing." Salvatore DeBenedetto, who experienced extensive combat, said, "I saw more than I wanted to. You know . . . as a young man, I saw thousands of naked bodies that were bulldozed into trenches extending for miles at Dachau; this is not something you forget very easily. It's been over 50 years, and it's hard to erase it from your mind. . . ." Bill Dirienzo recalled that "one of the most painful experiences was being one of the first GIs to get to Dachau. We were totally unprepared with what we saw and as history has noted, one of the worst crimes that could have been committed to man."

Ralph Barrale, a combat military policeman, arrived at the Huertgen Forest, the site of a series of horrific battles, in the fall of 1944. On his way to the rear to pick up mail with a mail clerk, Barrale saw the tragic result of those battles. "What we saw on our way back through the forest I will never forget," he recalled. "The engineers were using a bulldozer trying to widen the road, and they would un-earth bodies that had

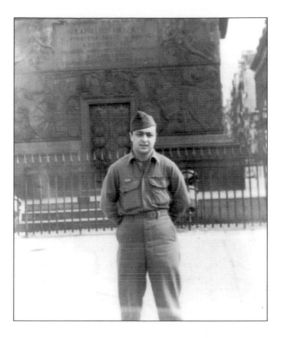

This is Lou Cerrone, 404th Fighter Group, Paris, France. (Courtesy Lou Cerrone.)

been laying there since the battle."

Tony Lima remembered the terrifying combat on Iwo Jima:

All the time that I was on Iwo and seeing all those Marines killed and some of them my best buddies, I could not understand why God was letting that happen; I kept praying for him to stop the entire killing. After a while another thing kept popping in my head; every night when things seemed to slack off I kept thinking, is tomorrow going to be my turn to die or get wounded, but as it turned out I happened to be one of the few who was spared both.

After almost two months on the island, Lima was very happy to leave Iwo Jima. When his troopship departed on March 27, 1945, Lima recalled, "We left the HELLHOLE for good. We were so happy to be leaving, but so sad to leave some of our best buddies there who will never leave."

Young men had always had a desire to experience combat. Al Conti, a combat medic who tried to enlist at age 17, said, "I couldn't wait until I went overseas and got into combat." However, he later regretted his

This is a tragic reminder of the human cost of war. Left to right are: Sgt. Oryll (killed in action), Corp. Korfitson (died of wounds), and Pvt. Mike Altamura in Columbia, South Carolina, 1943. (Courtesy Mike Altamura.)

rashness. "The first day I was in combat, I was sorry I'd made that commitment. It was horrible," he recalled. Pete Buongiorno recalled the nervousness that gripped even veterans as they entered combat:

You never hear too much about how guys crack up when moving into bad conditions, but I have seen many who had to be brought back when we moved up, but I tell you, you cannot blame them. The night we crossed the Rhine River, we waited for three hours near the shore bank, and the thinking starts to work on you. I shook and my teeth were chattering for the three hours, but when you move out and you start to cross, you settle down, and then you are OK 'til the shooting is over. It's amazing.

Lou Cerrone, serving as an Air Corps radio operator with a forward air control party attached to the Third Army, recalled his feelings in combat. "I have to admit that I always was scared, but I did my job," he said. "I believe that fear is your friend [because] it increases your reflexes and strength."

Of course, not all men served in combat. Due to the truly global nature of the war, and the far-flung responsibilities of the United States and her allies, servicemen were stationed all over the world. Albino Santelli served with the 391st Quartermaster Battalion in the Fiji Islands. Arriving there in September 1942, Santelli remembers it as the most gorgeous place in the world. "We played golf, swam, and had a boat," Santelli recalled of his duty with the small 16- or 17-man U.S. Army garrison. The men lived in a two-story oversized hotel near the beach. Luckily, one of the men, fellow Italian American Joe Messina, happened to be a world-class chef from Cincinnati. Thus, for about one year, the men ate very well. There was no shortage of produce, and Messina worked wonders. The Navy Seabees had built a supply depot on Fiji, and U.S. Navy ships still docked at the port, but soon the war passed Fiji by. Although General MacArthur occasionally used the island for meetings, Santelli recalls that sometimes the men wondered just what good they were

doing there. Although the setting was certainly somewhat idyllic, the isolation and monotony could also take its toll. Only one man of the garrison managed to leave the island during the war (he was selected for Officer Candidate School); Army headquarters in the Pacific turned down all of Santelli's requests for furloughs. Santelli didn't leave the island until the end of July 1945.

Tony Ingrisano, serving as an Air Forces officer at Childress Army Air Base, Texas, had finally had his fill of stateside service. "I was a career soldier, and I didn't want to spend the war in the Training Command," he recalled. Ingrisano requested an overseas combat assignment, but the best he could get was an assignment to Panama as an adjutant. Ingrisano remembered that the housing was great. "I was billeted with a major and two other captains. The major and one of the captains were in the Quartermaster Corps, so we always had a full refrigerator," he said. Still, he wasn't satisfied. "I couldn't see myself sitting there shuffling papers," he recalled. Finally, he volunteered for an assignment to be a squadron commander on the Galapagos Islands, on the equator off the coast of Ecuador in western South America. The U.S. military's original mission there was to provide an early warning base for protection of Panama; by the time Ingrisano arrived there in the summer of 1945, this mission was largely obviated. Ingrisano served there for the remainder of the war.

Gill Fox, the infantryman and erstwhile cartoonist, served with the 253rd Infantry Regiment, 63rd Infantry Division, in combat during the Battle of the Bulge in late 1944. Although his principle duty was to maintain his company's maps during combat, he had gained quite a bit of favorable attention due to his cartoon creation. Fox's cartoons depicted the escapades of a soldier called Bernie Blood (the nickname of the 63rd Infantry Division was the Blood and Fire Division, due to its insignia, which depicted a flame and drop of blood on a sword blade). "I used a lot of female gags and sex gags," Fox

Gill Fox's "Bernie Blood" cartoon appeared in *Blood and Fire*, the newspaper of the 63rd Infantry Division. Fox's editor said this particular cartoon was the most reproduced cartoon during the war—it was made into posters in Europe, the Pacific, and the United States. (Courtesy Gill Fox.)

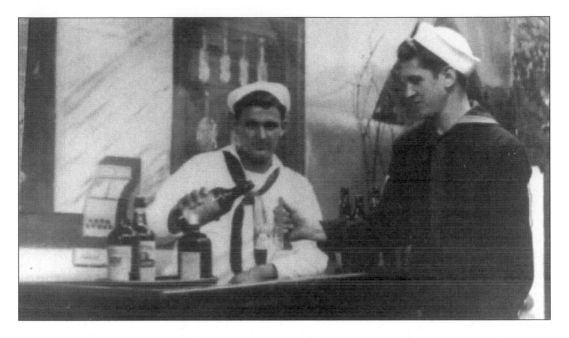

Mario Minervini is shown at right with a friend. (Courtesy Mario Minervini.)

recalled, "and the General thought it was great for morale." Soon, Fox was detached for duty with the *Stars and Stripes*, the official soldier's newspaper in the Theater. He continued to supply cartoons to the 63rd Infantry Division newspaper, in addition to drawing for *Stars and Stripes*. "It was an incredible experience because of all the newspaper professionals working around me," he remembered.

Joe Jacovino served as a GI entertainer with the Sixth Special Services Platoon in the European Theater of Operations. Jacovino sang, danced, and composed music for the group. According to Jacovino, the men "were not assembled to be a combat unit, although all of us were either trained combat engineers, infantry men, signal corps etc. The Army saw fit to assemble us as an entertainment unit after the original members began entertaining in the Replacement Depot we landed in." The Platoon recruited other talented soldiers and toured rear areas entertaining troops.

And combat action against the enemy wasn't the only hazard servicemen were exposed to. Training accidents and operational accidents all took their toll on

units. Mario Minervini, who enlisted in the Navy at the age of 17, served in the Armed Guard. The Armed Guard provided small U.S. Navy detachments, consisting of gun crews and radio personnel, to provide protection for merchant ships engaged in the extremely hazardous cargo runs to foreign ports. On one such run, while his ship was in U-Boat-infested water off the coast of Florida, Minervini was scheduled to go on watch. "For some reason, our commanding officer ordered that the watch carry pistols, so we carried loaded .45 pistols," he recalled. Minervini came to relieve his friend on watch. Before turning his pistol over to Minervini, his friend pulled the slide back, thus chambering a round, and removed the clip. Minervini's puzzlement turned to fear as his friend, thinking the pistol was empty, pointed the pistol at him and pulled the trigger. The round struck Minervini in the upper thigh, the force driving him against a gun shield. Not knowing where or how badly he was hit, Minervini thought, "I'm only 17, and I haven't lived yet. I don't want to die." The wound was severe, but there were no

Mario Minervini, left, and a friend register with an American Red Cross worker. (Courtesy Mario Minervini.)

doctors aboard most of the merchant ships, and Minervini spent a tense and sleepless night aboard the ship. He was dropped off the next day at Guantanamo Bay, Cuba, where he spent a month recuperating at the Navy hospital. "Someone was watching over me that night," he recalled.

U.S. Navy sailors performing armed guard duties aboard civilian merchant vessels were constantly aware of the danger posed by German U-Boats lurking just beneath the water's surface. An attack could come at any time, from port in the U.S. to the port of destination. Mario Minervini remembered one convoy run when his vessel broke down in the North Atlantic. The convoy pressed on while Minervini's ship stayed dead in the water for two days, the men sleeping and eating at their battle stations, expecting to be attacked at any moment. "We were great bait," Minervini remembered. Another time, while taking troops to Casablanca, Minervini had the bow watch. As the ship passed through the Straits of Gibraltar, Minervini was engaged in a pursuit common to sailors since ancient times—watching porpoises follow the ship. He watched as one porpoise cut across the path of the ship; seconds later he was startled by a loud explosion, and all hands went to General Quarters. Soon, they learned that an enemy officer had reported their ship sunk, and Minervini surmised that the porpoise he saw cut across the ship's path was actually a torpedo fired by a U-Boat crew. The torpedo missed and exploded on shore; the U-Boat captain, out of torpedoes, reported an enemy vessel sunk.

At the age of 17, Dom Manobianco was a petty officer, third class in the Coast Guard. He served on vessels in the Pacific and European Theaters, and participated in convoys aboard an escort ship. He recalled his usual combat duties: "I was a radio operator normally, but during sub contacts or general alarm my post was a K gun, which fired depth charges." In common with many men, he recalled his apprehension during his first combat experience: "When I first experienced General Quarters, it was on

Dean Belmonte, 292nd Engineer Combat Battalion, is pictured here. "Taken March 25, 1945, somewhere in Germany." (Author's collection.)

[my] first convoy; to say I was not afraid I know it [would] be a lie." Aboard ship, constant attention was required, regardless of weather conditions. "In the winter months, the cold in the North Atlantic and the water spray over you, you get covered in ice, and your hands almost get too numb to set the depth charges."

The stress and strain took its toll on some men. When Minervini's vessel put in to Bristol Harbor in England, they were attacked by a lone German bomber that jettisoned its bombs over the port. The gunners aboard Minervini's vessel opened fire and brought down the bomber. "Everyone, Navy guard and merchant sailors, stood by their posts, except the Navy officer in charge. He hid himself, and was in disgrace from then on," recalled Minervini.

This is Mike Ingrisano, 37th Troop Carrier Squadron, "Tel Aviv, Palestine, October, 1943." (Courtesy Mike Ingrisano.)

In the course of his service, Minervini watched ships in his convoy being attacked; he watched helplessly as some sunk extremely quickly. Often, the convoy was under orders to keep going and not to stop to pick up survivors. "My heart would be in my throat, and I'd think, 'Oh, those poor guys.'" He recalled. He summed up his feelings: "To survive four years and not be sunk was remarkable."

Keeping in Touch with the Home Front

Keeping in touch with loved ones has always been important to men and women in the service. Mail to and from home was always an important factor in morale. The regularity of mail delivery was a high concern among the men and their leaders. The quality of the mail service depended upon many factors. John Mangione, serving in New Guinea and the Philippines, remembered the mail service as "spotty, at best." Frank Carnaggio, serving in Europe, said that the mail situation "wasn't bad at all. Someone 'higher up' must have known how important mail was to morale. We had 'mail call' every day. All communications from home or from relatives serving in other theaters of operation were eagerly awaited."

Sometimes local newspapers kept the homefront informed by publishing stories of hometown boys in service. Dean Belmonte had been a lens grinder for Bell and Howell before being drafted in 1944. He kept in touch with his former co-workers by writing to the company newsletter, the *Finder*, which published his letters from England. Later, Belmonte's local paper wrote a short notice of his participation in the Roer River crossings in 1945, where Belmonte's unit, the 292nd Engineer Combat Battalion, had constructed two bridges under enemy fire. Frank Fantino was also the subject of local news stories for his extensive combat in the Philippines. Likewise, Air Forces pilot Ed Imparato was interviewed by his local paper during a brief leave period in 1944. Mike Ingrisano, returning to the U.S. at New York Harbor in May 1945, recalled, "I had been interviewed by a *New York Times* reporter in NY Harbor. When I reached Fort Dix, I called home, only to be told that they knew all about it. Heard the interview on the radio."

Encounters with Enemy Soldiers

Vince Consiglio, undergoing training at Camp Swift, Texas, came across Italian prisoners of war (POWs) at that base. "They wore clean, white shorts and were eating three squares a day; they never had it so good," he recalled. Sam Mastrogiacomo, flying as a B-24 gunner on the way to Europe, came across Italian POWs working as cooks in the mess hall at an American air base in Dakar, West Africa. "The food was very good there," he recalled. Afterward, Mastrogiacomo spoke with some of the men. They were anti-aircraft gunners who had purposely missed while firing at American airplanes; they were all glad to be prisoners and away from combat. Al Panebianco also saw Italian POWs "working in Africa helping to dish out the food to hungry American soldiers who were en route to the front." Pete Buongiorno came across Italians who had been forced laborers in Germany. He recalled, "I talked to a few in my best Italian, and they said when the war started they happened to be in Germany and were not allowed to go home."

Mike Ingrisano, a C-47 aircrew member, also encountered Italian POWs. "We had two Italian prisoners who attended our mess in Tunis. On Thanksgiving, they got as drunk as the rest of us and all ended singing Italian songs," he remembered. Ingrisano remembered, "another occasion, when I was in Naples, an Italian soldier who had just returned from the Russian front was no longer in the service, asked me if I could manage to sneak him aboard my plane. He was from Sicily, and needed to get across the Straits of Messina. I put him in my Radio Operator position, and then we dropped him off in Sicily. . . [we] were constantly doing these small services whenever we could accommodate any foot soldier."

Dean Belmonte, while serving in an engineer combat battalion in the European Theater of Operations during the final push into Germany in 1945, came across German prisoners. He recalled that they were quite militaristic and arrogant, even in captivity. Other Italian Americans had similar experiences. In combat in Italy, Al Panebianco was detailed to escort a group of 21 German prisoners to the rear. According to Panebianco, the men "were well disciplined and happy to leave the combat area. Fortunately for me, I did not have a problem with any of them."

Often, as the 750th Tank Battalion passed through a town in pursuit of the retreating Germans, they would, in their haste, bypass pockets of German soldiers left in the town. These Germans would then pose a serious threat to follow-on personnel such as Mike Altamura and other maintenance troops. Once, Altamura came upon a surrendering German lieutenant in just such a situation. Altamura took the German's watch and gun. The man became angry and protested to Altamura, claiming his actions were against

Mike Altamura poses with the Berlin Bound, a tank from his unit, the 750th Tank Battalion, Berlin, 1945. (Courtesy Mike Altamura.)

Ralph Barrale, 821st Military Police Company, is pictured near Maastricht, Holland. (Courtesy Ralph Barrale.)

investigation, it was found that the men were SS troopers. Altamura's commander told him, "Corporal, we have orders to take no prisoners." Horrified, Altamura replied, "You shoot the sons o' bitches yourself." The commander told Altamura and another man to tie the prisoners and keep an eye on them for the night. "The Germans were so nervous, they befouled themselves," recalled Altamura. Eventually, an MP unit came and took the prisoners away. "I later heard they had been shot while trying to escape from the MPs," Altamura remembered.

Military police were charged with the handling and processing of prisoners of war. Ralph Barrale, an MP in the European Theater, recalled his encounters with German prisoners.

May 2, 1945, we entered the town of Dorfan, and actually took the town before the armored units and infantry came in. We went from house to house taking German Soldiers prisoners; I could not believe it, they were still asleep when we entered the town. German soldiers were surrendering by the hundreds, and our PWE (Prisoner of War Enclosure) had thousands every day. German officers were surrendering their entire commands, and it became a common sight to see an entire company of German soldiers march through the streets of Dorfan to give themselves up at our PWE.

The willingness of some Germans to surrender is illustrated by another episode Barrale recounted:

One day as Cpl. Walter Hipp and I were coming back from posting some MPs on traffic duty, we saw a deer in the woods; we thought wouldn't it be good to have some deer meat to eat. So, we opened up with our carbines, never did know if we hit it because 15 Germans came running out of the woods with their hands up; they had been hiding in the woods trying to make their way home; we took them back to town as prisoners.

the Geneva Convention. "I had never read the Geneva Convention, and I didn't give a damn. Besides, he could use that watch for timing artillery barrages," he recalled. Although Altamura still had the German's gun almost 60 years later, the watch never made it. "Two weeks later, I dove into a bomb crater during an artillery barrage, and the watch broke," he said.

Another time, during the Battle of the Bulge, Altamura found himself alone near a stand of woods. Hearing cracking noises in the woods, Altamura knelt down and pointed his Thompson sub machine gun at the woods. Two Germans came out, their rifles not at the ready; when they saw Altamura, they immediately dropped their weapons and surrendered. Altamura took the men to his company commander. Upon

During the final days of the war in Europe, Sam Lombardo's unit, in their rapid pursuit

Sam Speranza, 254th Infantry Regiment, 63rd Infantry Division, is pictured at right with one of his unit's sergeants. (Courtesy Sam Speranza.)

This is Pete Natale, 30th Signal Battalion, Heavy Construction, in Naples, Italy, 1943. (Courtesy Pete Natale.)

of the retreating German army, captured a veterinary hospital. "No one had any weapons, so we just let them go. What are you going to do with a veterinary hospital?" he recalled.

Dom Constantino remembered an encounter with a captured Japanese soldier who was being transported aboard his ship, the USS *Pinkney*. Constantino went to the brig, where the prisoner was kept, to see if the man could speak English. It turned out that the Japanese soldier could, in fact, speak English, and Constantino traded some candy to him for a few Japanese coins. Constantino asked the man where he lived, and the man drew a map and picture, complete with some Japanese words, for Constantino. Years later, Constantino had the Japanese characters translated. "I became real sad," he recalled. "The man had written, 'This is my home, and I wish I were there now.'"

Fighting against Italy

How Italian Americans felt about the possibility that they might have to actively take up arms against Italians varied. Probably a lot depended upon the man's age, his background and experiences, and branch and location of service. While in training, Tony Pilutti actually had to sign a waiver stating that he would fight against the Italians if necessary. His cousin, who shared Pilutti's birthday, was, at that time, a soldier in the Italian Army. Pilutti signed the waiver, figuring that he would most likely be fighting the Germans, and that Italy was almost out of the war anyway. He had mixed feelings about the possibility of fighting against the Italian Army. Bill Donofrio, an infantryman in the 70th Division, recalled that, during his induction physical, "I was asked if I would object to fighting against Italy, to which I answered no. That, and being asked if I liked girls were all I recall about any interview."

Dom Porcaro was born near Naples in 1922. He came to the United States in 1931, and received derivative U.S. citizenship because his father was an American citizen. Inducted in 1943, and ordered to join the Marines, he managed to join the Navy and become an aviation machinist instead. Although he served in the South Pacific, he didn't relish the possibility of fighting against Italians. "I did wish that I would not have to do that. I was happy that I was sent to the Pacific Islands (instead of Europe)," he recalled. Armand Castelli stated that his feelings were mixed "at the thought of having to possibly kill my own blood. . . maybe my own relatives. I took a very detached view about the matter because they probably felt the same way. [German Americans] felt the same way, but we were Americans above all." Sam Speranza, who fought against Germans in Europe, reflected another view that must have been held by most Italian-American servicemen. "I was happy not to fight against Italians, but not happy to fight anyone," he said.

Pete Natale is shown at right with Sgt. Cornell, Italy, 1944. (Courtesy Pete Natale.)

John Mangione never gave the matter much thought, since he was sure he wouldn't be fighting in Europe, but he wouldn't have liked the idea of fighting against Italian soldiers. Sam Mastrogiacomo, a B-24 crewmember in the European Theater, felt much the same way. Dom Manobianco, the Coast Guardsman who served in the European and Pacific theaters, echoed the sentiment: "I never gave it a thought about fighting the Italians. I guess it would have been different if I was a foot soldier and fought in Italy." Mike Ingrisano reasoned that "like with the German Nazi, the only 'bad' Italians were the Fascists." Warren Sorrentino, an infantryman, said, "I had a strong desire to survive; regardless who the enemy was, I would shoot to kill. It was a matter of survival. So I had no qualms about fighting the Italians." Jim Caruso, a combat medic, summed up the thoughts of many Italian-American servicemen regarding fighting against Italy: "They were the enemy against my country."

Ed Imparato stated he had no reservations about his service and the possibility of fighting against Italy. Likewise, Vince Consiglio never gave the matter a thought. He loathed Mussolini, and he felt that the Italians had no real desire to fight anyway. Mike Altamura also had no compunction about fighting Italians. "If I had to fight them, I would," he recalled. "After all, I was an American. I was more worried about the general idea of killing another human being, regardless of nationality." Likewise, Al Miletta, an aircraft armorer with the 81st Fighter Group, recalled that they never considered themselves Italian; rather, "we were American soldiers doing a nasty job, and we did it proudly." Al Panebianco recalled that, at the induction center, "every individual was asked if he had any reluctance fighting in Europe or the Pacific. Based upon your reply, you were sent to either theater of operations. I did not object to fighting in Europe. Hence, I was sent to Italy." Commenting on the possibility of fighting against Italians, Pete Natale summed up his feelings, which were probably held in

U. S. Army Hospital Ship, Frances Y. Slanger

Lou Cerrone returned from Europe after the war aboard the United States Army hospital ship, Frances Y. Slanger. *(Courtesy Lou Cerrone.)*

common with most Italian-American servicemen: "You had to do what you were ordered to do."

Hal Cenedella, the Navy diver, recalled that "there were no Italian Americans, French Americans, or German Americans; we were all just plain Americans. There was no animosity toward anyone." However, some men did experience harassment because of their Italian ancestry. Armand Castelli, undergoing infantry training in the spring and summer of 1945, recalled that the only other Italian American in his company was something of a disgrace. The man complained of a trick knee and that he should never have been drafted. "The others in the company kept on making remarks about the Italians being lousy soldiers, especially the way the Italian army fought," Castelli remembered. Although he was treated fairly by the training officers and NCOs, Castelli took all this talk as an insult. However, after Castelli was one of the few men to qualify as a Marksman with the M1 rifle, "the insulting remarks about the Italians ceased."

Families

As with families all over the country, World War II deeply affected Italian-American families. In Little Italies all across the nation, sons, brothers, and fathers left home and family to serve in the military. Often, more than one man from a family left to serve. The stress and strain this must have caused on these families is evident when we look at individual cases. For example, in Herrin, Illinois, eight brothers of the Faro family served in the U.S. armed forces during the war. Two brothers served in the Army, five in the Navy, and one as a bomber crewmember in the Army Air Forces. Incredibly, all eight brothers survived the war. And eight brothers and one sister of the Scerra family from Gardner, Massachusetts, served in the U.S. armed forces during the war. One of the brothers, Joseph A. Scerra, later became the Commander-in-Chief of the Veterans of Foreign Wars, a prominent national veterans group. Other cases were less drastic, but by no means less traumatic, for families.

Albino Santelli, who served in Fiji during the

Shown here is the Ingrisano family reunion, May 1945. From left to right are: (standing) Tony, Ted, Lou, Tom, and Mike Ingrisano; (seated) Sheila (Tony's wife), Louise (Ted's wife), Sally (Lou's wife), Lucy Ingrisano (the men's sister), and Betty Jeane (Mike's fiancée). The photograph was taken in the room used as a waiting room for Dr. Lou Ingrisano in the family home in Brooklyn. (Courtesy Mike Ingrisano.)

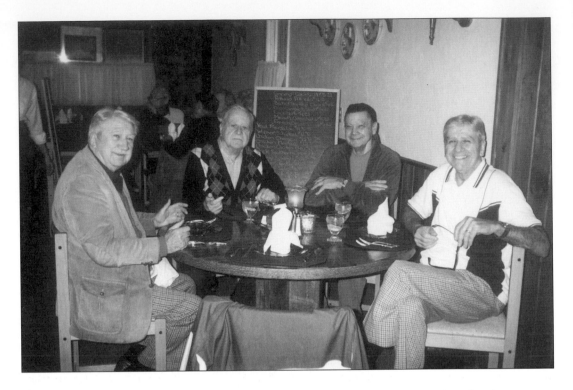

Left to right are: Tony Ingrisano, Dr. Lou Ingrisano, Fr. Tom Ingrisano, and Michael Ingrisano at a restaurant in Middletown, New York, October, 1987. (Courtesy Mike Ingrisano.)

war, had two brothers in the service. Brother Alfred served in the U.S. Navy Service Corps at Pearl Harbor, Hawaii, where his duties included participating in entertainment shows for the troops. Another brother, Frank, served as a navigator on bombers participating in raids on Rumanian oil fields. Pete Natale had three brothers who were also in the service. One brother survived when his aircraft carrier was sunk in the Pacific; another brother served in the 90th Infantry Division and was a POW; the third brother served on a Navy destroyer in the Pacific. "Our mother went to church every day to make Novenas," Natale remembered.

Paul DeCicco, who served in an armored engineer battalion in Europe, had two brothers in the military. One brother was a First Sergeant in a medical unit in the Pacific, and the other served aboard a U.S. Coast Guard destroyer escort. He remembered, "My mother had three sons, all in combat assignments, and you can bet she did a lot of

praying in those days. We all got home safely, so someone was listening." Sam Mastrogiacomo, the decorated B-24 gunner who was shot down and interred in Sweden, had two brothers, identical twins, who served in the 75th Infantry Division. The twins were both wounded during the Battle of the Bulge, one day apart. "My mother first received notice that I was missing in action, then she received notice that her two other sons had been wounded. Mothers took the brunt of the punishment during the war, more than any others," he commented. Of his own mother, Mastrogiacomo recalled, "When I got home, she looked 20 years older than when I had left." Dom Manobianco concurred: "My mom aged, and I know she suffered more than I ever did. My father was always there for me, and he knew I left as a boy and came home a man."

Fathers also suffered at home while their sons fought overseas. Lou Cerrone, who had become ill in Europe after the war, returned

home as a patient aboard the Army hospital ship *Francis Y. Slanger*. He ended up in a hospital in Galesburg, Illinois, near his home in Chicago. Cerrone recalled:

My father was alone (because my mother died when I was 17) after my younger brother Anthony went into the Navy shortly after his 17th birthday; he was aboard the light cruiser Columbia *in the Pacific Theater. I never told my Dad when I got hurt. I didn't want him to worry any more than he did with both of us overseas. I wasn't aware that the Army advises the family when an injured service man arrives at a hospital near his home. The day after I arrived in Galesburg I was in the dorm playing cards and my Dad and Cousin Rose come walking in. What a surprise when I saw them. My Dad, Cousin Rose, and I were bawling like babies. He was angry and happy at the same time. I had a hard time proving that I was going to be okay.*

John Mangione, who served in the Pacific as an artillery gunner, had two brothers who served in the Navy. One brother was at Pearl Harbor during the attack on December 7, 1941, and another brother was on a ship that was sunk off Okinawa. Dave Azzari's brother, "the only one in the family to go to college," served in the Army Air Forces. Brothers Vince and Frank Carnaggio were happy to both return home alive. Al Panebianco, upon returning home from the European Theater, met his older brother who was on his way overseas. They were able to enjoy dinner together before the older brother went to Germany, where he was shocked to see the destruction so recently wrought. Hal Cenedella's brother served in the infantry and was wounded at Anzio. Art Pivirotto, the Navy B-24 bow gunner, had a brother who was an instructor navigator with the Army Air Forces. Mike and Tony Ingrisano had another brother, Lou Ingrisano, who also served during the war as a doctor with the 41st Infantry Division. Warren Sorrentino had three brothers in the service during the war. Al Miletta had two brothers who were also in the Army; all three brothers returned home safely. Stephen Budassi had two brothers who also survived

service during the war, and Patrick Molinari had one brother in the Army Medical Corps.

Not all families made it through the war unscathed. Joe Jacovino recalled how he discovered that his brother, Angelo, had been killed in action:

We were returning to Etrechy, our base south of Paris, and because we hadn't received any mail for several days, the lieutenant decided to make a little detour and stop in Paris to see if any mail had been accumulating there. All the boys had gotten out of the trucks to stretch their legs and take a short walk. I stayed in the truck because I was feeling somewhat down because of the mail situation. Ricci and Suslavic returned, but they were looking at an envelope with a concerned look on their faces. Finally, Ricci approached the truck, handed me the envelope, and with a lump in his throat said to me, "I'm sorry, Jack." I looked at the envelope and what I saw made me feel like I had been hit in the head by a sledgehammer. "No," I screamed to myself. "It can't be true." It was a letter addressed to my brother Angelo, sent by me. In big black letters, stamped across the front was the word "DECEASED." I kept repeating to myself "It can't be true." The Army hadn't notified me. I hadn't received any telegram from the Red Cross. The lump in my throat was making it difficult to breathe. All of a sudden it dawned on me. If this is true, how did my parents, sisters, and kid brother react when they received notification? My emotions went into a tailspin. I dimly remember Ricci and Suslavic mentioning the letter I received to the boys as they returned. As they slowly got back into the truck, some brushed me on the leg, in a gesture of condolence, and others, in voices showing concern, said how sorry they were. As I was the only member of the group who had an immediate member of the family in harm's way, even in my dazed condition, I had the feeling that each and every on of them felt like they had lost a member of their own family. Such was the concern that we had for one another.

Salvatore "Tootie" DeBenedetto is pictured here. (Courtesy Tootie DeBenedetto.)

Promotions

During wartime, promotions could be maddeningly slow or alarmingly swift. Ed Imparato, who enlisted in the Army Air Corps Reserve as a private and then was commissioned a second lieutenant, received regular promotions while holding important leadership positions in the 374th Troop Carrier Group in the South Pacific. In November 1943, at the age of 26, he became the youngest lieutenant colonel in the theater. On December 11, 1944, at the age of 27, Imparato was promoted to colonel. Thus, in just over five years, Ed Imparato made one of the most rapid advances ever from private to colonel. He was surely on track to achieve general officer rank, but the end of the war resulted in the rapid movement and transfer of those senior officers who had taken a special interest in Imparato's abilities, and he remained a colonel. Imparato joked that "had I been a senior officer, I wouldn't have promoted anyone with my record, either."

Due to hundreds of vacant Non Commissioned Officer (NCO) slots in his unit, Bill Donofrio, training with the Eighth Armored Division at Fort Knox, Kentucky, in 1942, went from private to sergeant to staff sergeant in only eight months. More often, however, units suffering extensive casualties needed to fill leadership ranks by promoting survivors. Frank Fantino landed at Mindanao, Philippines, as a private first class with the 19th Infantry Regiment, 24th Infantry Division. Following extensive combat, two weeks later he was promoted to sergeant. Dave Azzari was promoted from private to staff sergeant and became a squad leader after his current squad leader was wounded in southern France. His company commander handed him staff sergeant stripes and told him, "Sew 'em on." Azzari said, "I was a good soldier; I'm very proud of that."

While serving in the 66th Infantry Division in the Lorient sector in France, Tootie DeBenedetto received shrapnel wounds in his arms and legs and one hand. While the medics

Bill Dirienzo is shown at left, along with two other radiomen from Company L, 30th Infantry Regiment, 3rd Infantry Division, Germany, 1945. (Courtesy Bill Dirienzo.)

were pulling shrapnel out of his wounds, his company commander approached him and said, "Take over Lieutenant, you're it." And thus did DeBenedetto, a technician fifth grade (T/5) at the time, receive a battlefield commission to first lieutenant. "I never had a ceremony. I guess it was because we were on the front lines for so long," he recalled. Jim Vitton's Assault Platoon repeatedly needed to be replenished. Once, the platoon was pulled off the line and sent to a beach to receive replacements. Vitton recalled his subsequent promotions: "While the re-organization back on the beach was occurring and we waited for our replacements, I was made corporal. We got our new guys, trained for a few days, and I was made a buck sergeant. Just prior to going back on line, we needed another staff sergeant, so I was given the position."

Jim Caruso is depicted here in a recent photograph.

Awards and Decorations

Tony Pilutti was awarded the Bronze Star for combat action in Holland. Reluctant to talk about the episode some 57 years later, he said, "Let's just say that I went out on a patrol; it was a successful patrol. Anyone would have done what I did." Sam Mastrogiacomo, who flew 13 combat missions in B-24 Liberators and shot down three German fighters, was awarded five Air Medals. Mike Ingrisano and Vince Guzzardi earned Air Medals for flying combat missions, as did Art Pivirotto and Ed Imparato, both of whom also earned the Distinguished Flying Cross. Sam Lombardo and Tony Cipriani both won Silver Stars, the nation's third highest award for bravery in action.

Bill Dirienzo, a rifleman and radio operator with the 30th Infantry Regiment in the 3rd Infantry Division, recalled how he won a Bronze Star for his actions during a fire fight in the Colmar area of France.

I was one of the radiomen for our Co. At this time I was not carrying the radio (it weighed about 30 lbs). George Sprague, who was one of the other radiomen, had the radio. As he was running to try to get into some sort of low spot, he was hit with small arms fire through his chest area. We needed that radio to continue communications with Battalion, so I ran, under heavy fire, to retrieve George, then went back for the radio under these same conditions. Don't ask me how I wasn't hit, even though I could feel and sense all the shots around me, with the ground being hit continually. Sprague was hit very bad, so I was trying to care for him and make radio contact. He looked like he was going fast. I put sulfur on the wound and a bandage over it. It was winter and snow on the ground, so I tried to keep him warm with our blankets. We wouldn't be getting any help unless I made radio contact with Battalion. The long antenna was lost, so all we had was the short one. That one doesn't go too far,

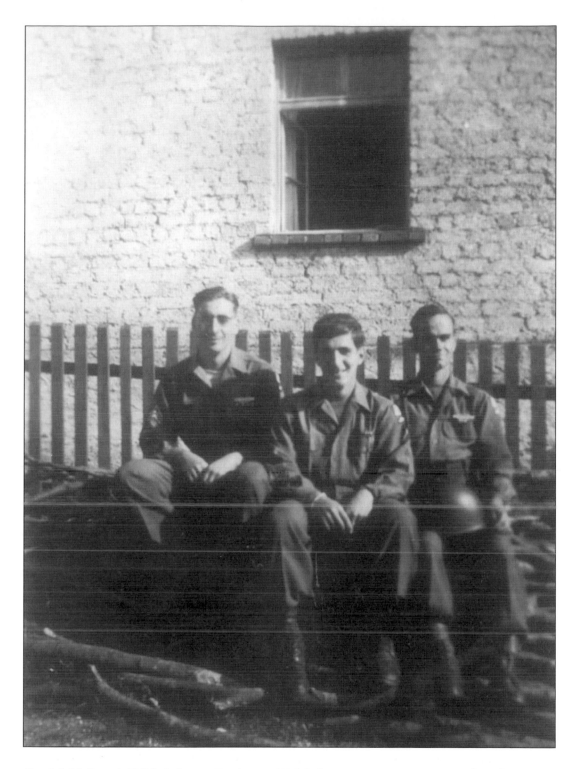

Patrick Molinari, 276th Infantry Regiment, 70th Infantry Division, is pictured in the center, with Sgt. Mastion at left, and PFC Wood, somewhere in Germany, 1945. (Courtesy Ken Molinari and Patrick Molinari.)

even on flat terrain. After a while, I don't remember how long, I finally made radio contact. Battalion, not being able to contact us, had moved out relay stations to make radio contact. So with George asking me, "Am I going to die?" and talking on the radio, giving coordinates, so they would be able to give us artillery support, we were able to pin down the Germans. When it got dark, they were able to get through to us with medical support, and we were able to evacuate our dead and wounded and get out of that area.

On March 21, 1945, a column of the 14th Armored Division was held up near Steinfeld, Germany, by "dragon's teeth." These were large concrete pyramidal obstacles deeply embedded in the ground, part of the vaunted "Siegfried Line." Paul DeCicco, of the 125th Armored Engineer Battalion, moved forward through an open field under intense enemy fire carrying a heavy TNT charge. DeCicco was able to blow open a gap; the tanks immediately rushed through and advanced against the Germans. For this action, DeCicco was awarded the Bronze Star. Tootie DeBenedetto, Sam Speranza, Stephen Budassi, Patrick Molinari, and Jim Caruso also earned Bronze Stars.

Another award treasured by infantrymen was the Combat Infantryman Badge. This was awarded for acquitting oneself successfully in combat, and it went to infantrymen only. Pete Buongiorno, who won the badge, recalled that award of the badge "also gave you a $10 raise a month, which gave a grand total of $60 a month pay." Combat medics also earned a Combat Medic Badge, similar to the Combat Infantryman Badge. Jim Caruso earned the Combat Medic Badge and declared that he was extremely proud of it.

Units as well as men could and did receive awards for battle participation. Units could receive presidential citations or foreign awards for valorous conduct during a given time period or during a specific campaign. Likewise, units as well as men earned credit for participation in various campaigns. Most men were justifiably proud of their units and were eager to relay that information. Mike Altamura (750th Tank Battalion), Dave Azzari (143rd Infantry Regiment, 36th Infantry Division), Dean Belmonte (292nd Engineer Combat Battalion), Dom Constantino (USS *Pinkney*), Mike Ingrisano (316th Troop Carrier Group), C.J. Lancellotti (137th Signal Radio Intelligence Company), Dom Manobianco (Coast Guard), Sam Mastrogiacomo (445th Bomb Group), and others proudly mentioned unit campaign credits or citations.

VICTORY, OCCUPATION, AND RETURNING HOME

Around the world, GIs greeted the end of the war with joy and reflection. Germany's surrender on May 8, 1945, was hailed as Victory in Europe Day (VE Day), while Victory in Japan Day (VJ Day) was celebrated on August 14, 1945 (the date Japan announced her intention to surrender to the Allies), although the formal surrender of Japan took place on September 2, 1945. Dom Manobianco recalled VE Day: "On VE Day I was at sea and on radio watch and received the message. We knew it was coming, but it was hard to believe after all the years of death at your door it was soon to be all over. Myself and another operator were on watch when the news came over; it was hard to believe we were going home after three years at sea." Patrick Molinari recalled that on VE Day he was "in Germany in the town of Westler, happy and drinking cognac."

On VE Day, Pete Buongiorno was in a hospital in France recovering from a shell wound in his right foot. He recalled the joy that the news brought to patients and staff alike: "Guys who were using canes and were in wheel chairs miraculously were able to walk again. The nurses passed out drinks, and everyone in the hospital was celebrating." After surviving the war, Lou Cerrone became ill while waiting to return home in Fritzlar, Germany, in August 1945. "My luck ran out at Fritzlar; I had a sudden collapse of my right lung; I was in great pain," he remembered. "I thought that I was going to die, but the flight surgeon quickly diagnosed the problem and assured me that I was not going to die. I was taken to a field hospital to begin a long stay in the hospital."

Sadly, Cerrone missed his unit's rotation back to the States, and he had to wait until November 1945 to return.

At war's end, men who were used to fighting, death, and destruction now assumed more peaceful duties. C.J. Lancellotti described his situation after VE Day: "When the war was finally over on 8

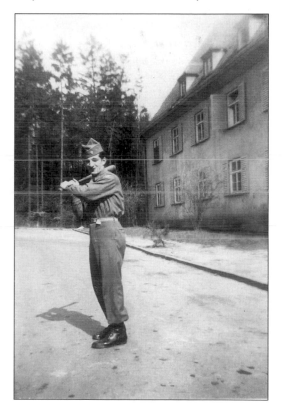

Patrick Molinari, 276th Infantry Regiment, 70th Infantry Division, demonstrates an American pastime in Germany, 1945. (Courtesy Ken Molinari and Patrick Molinari.)

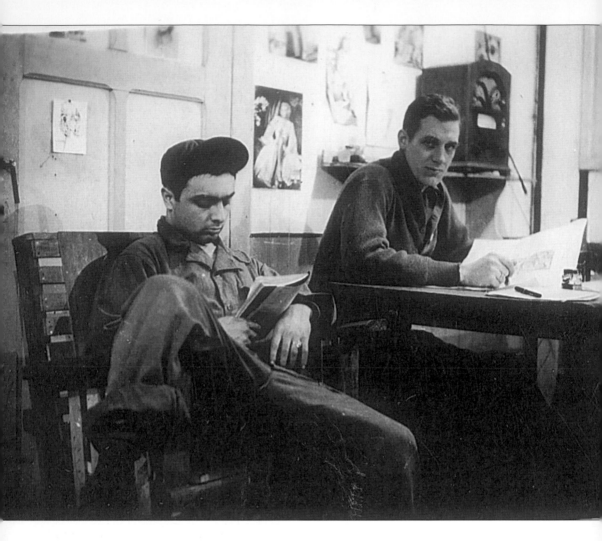

Lou Cerrone, left, is shown in the day room at St. Trond, Belgium, October 1945. (Courtesy Lou Cerrone.)

May, 1945, I was NCOIC of a direction finder near Lake Silbersee in Germany. This appeared to have been a small vacation place for the Germans. There was a main building and five or six small cabins surrounding a lake containing a couple of old rowboats. We passed some time on the lake fishing and enjoying the peace and quiet. We cleaned our equipment and awaited further orders from headquarters." Lancellotti received permission to return to England to marry the young lady he had met there in 1944. After a brief honeymoon, Lancellotti made his way back to his unit. Unable to track down his unit, which had moved out of Germany, he:

. . . took advantage of the situation and visited Notre Dame Cathedral, went up on the Eiffel Tower, and saw other sights. Finally, we ran into a man from the company who was on leave in Paris, and he told us the unit had relocated to Spa, Belgium. We rejoined the unit and awaited further orders. Soon we were told that, because the war in the Pacific was still going on, we were being shipped to the Pacific area to continue doing what we do best. In August, we proceeded to France, where we turned in our radios and direction finders. While we were at a processing camp, the atom bombs were dropped on Japan, and the war in the Pacific was ended.

The end of the war brought about the rapid demobilization of America's armed forces. Throughout the last half of 1945 and through 1946, men left the service in droves. Homecomings were joyous occasions full of family, friends, and food. Albino Santelli, stationed in the Pacific for almost three years, returned home to Chicago at the end of July 1945, and was married the next month. Dave Azzari remembered "veal cutlets and meatballs—a great homecoming!" Al Panebianco's homecoming "was a day I will forever remember. It was a day of happiness, joy, and tears." Some men experienced quieter, but no less joyous, homecomings. Frank Carnaggio returned to Birmingham, Alabama, at 3:30 a.m. on a day in November 1945. He went to a diner,

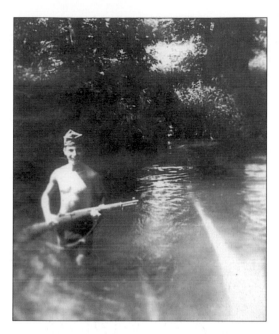

Sam Speranza, 254th Infantry Regiment, 63rd Infantry Division, was fishing for trout using his rifle: "They wouldn't bite on hook and line." This photograph was taken in Germany, 1945. (Courtesy Sam Speranza.)

where he drank coffee for about two hours before calling his father. "There were no flags or parades; I just wanted to get home," he recalled. Warren Sorrentino remembered his homecoming:

I came home August 3, 1945. I arrived at Camp Edward in Worcester, Mass. The next day, they let us out and outside the gate was my wife, my brother, and sister-in-law, who spent the night sleeping in the car afraid that they would somehow miss me if they weren't at that gate!! It was the greatest feeling in the world to be back on American soil, and having your family there greeting you. I had made it through five major battles, came home to my family with everything intact!! Truly someone was watching over me.

Even returning home could be hazardous. Al Miletta recalled his departure from Chengtu, China, in June 1945. "As we were leaving, our plane was the third plane in line. The first one took off and dropped back

113

Al Miletta is shown, safely home at last, in 1945. (Courtesy Al Miletta.)

down. The second one took off and exploded in mid-air. Then it was our turn." Nine days later, Miletta arrived safely in New York and vowed he'd never fly again.

Members of the U.S. Navy Armed Guard operated out of U.S. ports and therefore made many "homecomings." Mario Minervini, sailing many times from the Port of Brooklyn, said, "I loved to see the Statue of Liberty—I would get a lump in my throat when I saw it and be glad I made it back." Dom Manobianco, a Coast Guardsman who served on many convoys, reflected on making it home alive: "But when you see what happens to the others, you can only thank God you came home." Dom Constantino returned to the U.S. in July 1945, after two years in combat in the Pacific. Walking down Main Street in Alameda, California, he thought, "Wow, I guess this is what we were fighting for—everything was so peaceful." Dom Porcaro returned to the

U.S. aboard an escort carrier in June 1945. "When we passed under the Golden Gate Bridge, all the cars stopped and waved at us," he recalled.

Tony Pilutti finished his convalescence following his wounding in Holland in time to return to his unit, the 508th Parachute Infantry Regiment, as they became the Honor Guard for the Supreme Headquarters, Allied Expeditionary Force (SHAEF) in Frankfurt, Germany, in July and August 1945. His unit received orders to begin preparation for movement to the Pacific, but the war ended before they departed. Instead, Pilutti arrived back in the U.S. on November 2, 1945, to await discharge at Indiantown Gap, Pennsylvania. Men sometimes languished in the discharge centers for weeks while paperwork was processed and administrative procedures were followed. An officer in Pilutti's company, however, pled the men's case, and Pilutti received his discharge on November 7, 1945.

Mike Altamura was in Berlin with his unit, the 750th Tank Battalion, for VE Day. Soon, the usual rumors circulated among the men: The 750th Tank Battalion was destined for combat in Japan. Thankfully, the war ended before this became a reality, and Altamura and his unit settled into a routine as occupation troops. Unfortunately, Altamura's mother suffered a heart attack, and he departed Europe via airplane a few weeks ahead of his unit in December 1945. Mike Ingrisano returned to the U.S. aboard the liberty ship *General Brooks* in May 1945. According to him, it was an "easy sail." "All we had to do was go from one mess line to another—breakfast, lunch, to dinner. . . . [And] a great meal for Mother's Day by the Navy crew," he recalled.

Ever since the dropping of two atomic bombs on Japan, debate has centered on the necessity of that action. While scholars and military experts can disagree on whether an invasion of Japan would have been necessary without dropping the atomic bombs, it is clear that many of the men slated for that

This is the 750th Tank Battalion Maintenance Shop, Krupp Works, Berlin, 1945. (Courtesy Mike Altamura.)

invasion feel that those bombs saved their lives, and this shouldn't be discounted off-hand. Armand Castelli, awaiting the participation in the invasion as an infantryman on Okinawa, felt that way. Fifty-five years after the event, Castelli said, "I owe my life to the atomic bomb." Jim Caruso agreed. Caruso was in the U.S. en route from Europe to Japan to participate in the proposed invasion in August 1945. "Much to my delight, the atom bomb was used, and my trip to the Pacific was canceled. Thank God—one war is enough for anyone," he reported.

Tony Lima, serving in the Marines in the Pacific, said:

VE Day was great, but fighting in the Pacific, my thoughts were on the Japs and trying to get things done on this side of the world. VJ Day was one of the happiest days for me . . . we were training for the invasion of Japan, and all we kept being told was that it was going to be the bloodiest battle in

history . . . they were estimating one million Allies would be killed in the capture of the Japanese home islands. When the atomic bomb was dropped and Japan surrendered, you know we were the happiest people on earth.

Mike Ingrisano was on a C-47 cross-country flight, preparing for the invasion of Japan, when he heard the announcement of the end of the war in the Pacific. "Glad it was over," he recalled. "Now to start life as it was meant to be." Others no doubt shared those feelings.

Not everyone returned home immediately. Men assumed occupation duties while they waited for their turn to rotate back to the States. A man's return date was dependent upon how many points he had earned during his service. Points were awarded on the basis of such things as time in service, time overseas, decorations earned, campaign participation, etc. Armand Castelli, who arrived on Okinawa in the summer of 1945,

Armand Castelli's Christmas tree is pictured in Okinawa, December 1945. (Courtesy Armand Castelli.)

and had relatively few points, was assigned to the 238th Finance Disbursing Section in Naha. By Christmas, he had been promoted to sergeant and worked in the officers pay section. It wasn't until September 1946 that Castelli was able to rotate back to the States. Likewise, Hal Cenedella, the Navy diver, served in Hong Kong and Shanghai, China, after the war. He returned home and was discharged in 1946. Stephen Budassi became a first sergeant in charge of a German prisoner of war camp in Goppingen, Germany. "I was assigned there on August 8, 1945, as the acting first sergeant," Budassi recalled. "I served as the first sergeant until January 29, 1946. To this day they cannot find the record of the time that I served there; I'm still waiting for the correction to my war records."

Bill Dirienzo recalled his brief occupation duty with the 3rd Infantry Division in Germany. "When the war ended, we took over some of the better homes for our quarters and had civilians for maids and general duty, such as doing all the kitchen work and even office work, since we had to have people who could communicate between the languages. The division moved to Witzenhausen for occupation duty. There we were at the corner where the British, Russian, and American zone came together." Tootie DeBenedetto served briefly in the occupation forces. Stationed in Vienna, Austria, DeBenedetto opened a nightclub for allied soldiers. In the club, he "put together a band to entertain the troops; it did not last long because when the Russians came, they would not hang up their coats, hats, and armor to dance with the girls, so I ordered them thrown out." The Russians were thrown out through the window, and DeBenedetto's club was closed down within five weeks.

Occupation duty itself could be hazardous. Mike Altamura, serving as part of the Army of Occupation in the American

Zone of Berlin in 1945, remembered frequent run-ins with Russian troops. Russians would occasionally rob and even murder American GIs; Americans would retaliate. Altamura claimed that, as battalion armorer, "I was asked to supply replacement .45 caliber pistol barrels on more than one occasion when one of our men had a confrontation with a Russian officer and shot him." The offending bullet, when retrieved, could not then be identified by ballistics since it wouldn't match the markings produced by the new barrel. On one occasion, Altamura was caught in the middle of a fire fight between two drunken Russian railroad guards. Worried that their bullets would hit some of the fuel or ammunition in the area, Altamura was prepared to shoot the Russians and was prevented from doing so by an American officer only at the last second. Altamura also reported trouble with

Bill Dirienzo, 30th Infantry Regiment, 3rd Infantry Division, is pictured in Salzburg, Austria, May 1945. (Courtesy Bill Dirienzo.)

Russians in nightclubs. The drunken Russians "had a habit of shooting off their rifles rather randomly in the nightclub," Altamura remembered. "When the Russians were sufficiently soused and quiescent, we took their rifles and threw them out of the night club. That ended our fraternization with the Russians in Berlin," he remarked.

Despite the government's mad dash to demobilize and decrease the size of the armed forces, the military did offer some men enticements to stay in. The Navy offered Art Pivirotto a promotion and a bonus if he would agree to stay in the service, but he declined, saying, "I had a great time, and the Navy was a good service, but it was time to get on with my life." Similarly, the Army offered Armand Castelli a promotion to technical sergeant if he would stay in. Castelli said, "I would [have] considered it if I were

"Two Russian soldiers, Berlin, 1945." (Courtesy Mike Altamura.)

117

transferred from the Finance Section and sent to the language school at Fort Devens in Massachusetts. I was thinking that I would be sent to Europe, perhaps Italy, but I was told there was no guarantee of that happening." So he, too, made the decision to get out of the service. Tony Ingrisano was offered a promotion to major, but his wife and baby were sick. Anxious to be with his family, he turned down the offer and returned home for his discharge in March 1946. Warren Sorrentino, a veteran of five campaigns in Europe, was offered a commission as a second lieutenant if he would stay in the Army for one more year; he declined the offer and was discharged.

Jim Vitton was approached several years after the war:

Prior to Korea, a colonel came to my hometown, in civilian clothes, to see me. He said that they had been reviewing records and noted that mine indicated I had spent a lot of time on patrol behind enemy lines. He said they needed men with that specialty and would be glad to take me back in at no less a rank than First Lt. for a special assignment. He said they would ship me and the family to Japan. That I would be separated from them for long periods, could return for a period, and then be gone again, etc. I told him I would have to discuss it with the family. He said to call him at Fifth Army Headquarters after I decided. I decided against it. I didn't think I could do much covertly in the Far East as a white person would have a major problem trying to be covert in a non-white country. So, I didn't bother to call him back. After a time, he called me. I told him I had decided against it. He thanked me and hung up.

Mike Altamura displays a "painting in our night club—painted by a German painter, Berlin, 1945." (Courtesy Mike Altamura.)

POSTWAR

Some Italian Americans stayed in service after the war. Ed Imparato remained in the Army Air Forces and eventually retired from the U.S. Air Force as a colonel in 1963, after 25 years of service. Sam Lombardo stayed in the Army and went to Japanese language school. He served in the Korean and Vietnam Wars before retiring as a lieutenant colonel. Dom Constantino rejoined the Navy in 1948. Posted to shore duty in Panama, he protested: "This is no place for a sailor; I want a ship." In 1950, he was given an honorable discharge only two months before the start of the Korean War. Tony Pilutti, wounded paratrooper veteran of two combat jumps, joined a Mississippi National Guard Quartermaster unit in the 1950s. He later transferred to a Special Forces unit and then made his first parachute jump 18 years after his last jump in combat in Holland in 1944. Pilutti eventually retired as a Command Sergeant Major with 105 total parachute jumps. He was proud of his service during the war, and he felt that all able-bodied me should have served. C.J. Lancellotti re-enlisted in the Army in 1947, and retired as a master sergeant in 1964. Dom Manobianco, who served in the Coast Guard from 1942 to 1946, was called to active duty in the Navy during the Korean War from 1950 to 1952. Frank Fantino also returned to the Army and served during the Korean War.

Upon his return home in December 1945, Mike Altamura met a board of colonels and was given a direct commission as a second lieutenant in the Army Reserve. He was called back to active duty during the Korean War and served as the commander of a black tank company at Camp Polk, Louisiana, and then ran a leadership school for black and white troops. Altamura was disenchanted with the way the Army and the government were conducting the war in Korea. He served on active duty only 18 months and then left the reserves. After this, he returned home and went to medical school and became a family practice physician. Tony Ingrisano, who had prior military service dating back to 1929, rejoined the Air Force in 1949. Although he was a captain when he was discharged in 1946, all that was available in 1949 was the rank of staff sergeant. "I told the recruiter, 'I'll take it,' and he nearly fell off his chair," he remembered. Ingrisano eventually retired from the Air Force in 1961, as a lieutenant colonel with 23 years of service.

Command Sergeant Major Tony Pilutti is pictured about 1974. (Courtesy Tony Pilutti.)

Paul DeCicco is shown in 1995. (Courtesy Paul DeCicco.)

Most men returned home eager to shed their uniforms and pick up their lives where they left off. Vince Carnaggio, who left high school and enlisted in the Navy at the age of 16, completed high school ("They had special courses for returning veterans," he said), college, and medical school. Deeply affected by his experience dealing with wounded and dying Marines at Tarawa, he became a successful pediatrician in an effort to help others.

Paul DeCicco, who performed demolition work with the 125th Armored Engineer Battalion, earned bachelor's and graduate degrees in civil engineering after the war. He became a full professor of civil engineering at Polytechnic University in New York, and was editor of the *Journal of Applied Fire Science.* DeCicco also committed some of his memories to paper, writing several poems about his experiences. Mike Ingrisano became a historian and wrote a history of a Union artillery regiment during the Civil War; he also wrote a history of his unit, the 316th Troop

Mike and Nancy Ingrisano are pictured at the ground-breaking for the World War II Memorial, Washington D.C., November 11, 2000. (Courtesy Mike Ingrisano.)

Lou Cerrone is standing third from left at a reunion of the 404th Fighter Group, Knoxville, Tennessee, 1993. (Courtesy Lou Cerrone.)

Carrier Group. After his retirement from the Air Force, Ed Imparato became a successful businessman and, following his second retirement, wrote at least six books on various aspects of World War II history, including his own memoirs and unit history. From 1989 to 1992, Sam Lombardo laboriously composed a hand-written account of his war service; the account was published in 2000.

Art Pivirotto, who had been an apprentice plumber when he had joined the Navy, returned home and completed his apprenticeship. He opened his own plumbing business and was still active into his late 70s. Dave Azzari eventually went into politics and served as the mayor of Swedesboro, New Jersey, for almost 20 years. Gill Fox became a syndicated cartoonist with Scripps Howard; he drew political cartoons for Connecticut newspapers into his 80s. Lou Cerrone earned a degree in architectural engineering and enjoyed a successful 35-year career as an architect.

Sam Mastrogiacomo finished high school after his service. He served in the Army and the Air Force Reserve for 33 years before his

retirement. In 2001, he became a volunteer working on the USS *New Jersey* as it was being made into a floating museum. Thus, he worked on the same vessel that he been

Frank Fantino is depicted here in a recent photograph. (Courtesy Frank Fantino.)

John Mangione is pictured with his great-grandson, Jonathan Mangione, 1999. (Courtesy Jon Mangione and John Mangione.)

working on in 1942, when he left to join the Army.

Many of the men remained interested in veterans' affairs. Al Panebianco maintained a small Internet website devoted to his military experiences. Sam Mastrogiacomo maintained an Internet website for air crewmen who had been shot down or forced down and interred in Sweden during the war. Frank Carnaggio served as editor of the Ninth Air Force Association journal. Mario Minervini was also active in the USN Armed Guard association. Other men were members of such veterans' organizations as the American Legion, the Italian American War Veterans, or the Veterans of Foreign Wars.

The willingness of men to talk of their experiences probably fluctuated with time. Many men were grateful to get out alive, and didn't feel like rehashing their experiences until much later in life when children or grandchildren became curious. Dean Belmonte served as a construction foreman with the rank of corporal in the 292nd

Engineer Combat Battalion in the European Theater of Operations in 1944 and 1945. He was always reluctant to talk about his combat experiences, harrowing near misses, and the privations he and his men suffered, but he spoke with pride about the fact that his unit had won a battle star for participation in a certain campaign. As late as 2001, some men remained reluctant to discuss any aspect of their service even though more than 50 years had elapsed since the performance of that service. "I don't want to talk about it," declared one veteran who had won a Silver Star for bravery in Europe.

Al Panebianco reflected on the fact that the reluctance of some men to speak about their experiences has impacted their own family: "I am saddened [by] requests from children and grandchildren asking and searching for information about their loved ones who served in the military during World War II. To this day, there are still many men who do not want to think or talk about their war experiences. I know we should respect their wishes, but their families are left with a missing link wanting to know what their Dad did during the war. I guess some of them will never know." Frank Fantino said, "I wrote my story for my sons and grandchildren and nieces after reading some request that were made from children of GIs that had passed away. Their stories were lost forever." Knowing this, Panebianco, Fantino, and others recorded their memories for their families. Speaking of the importance to record this information for posterity, Al Miletta said, "They may forget who we were, but they will never forget what we did."

The men who served did so out of a sense of duty, and they served proudly. As Dom Manobianco recalled, "I was proud to have been fortunate to have served in the military. I became part of team that knew we needed each other to survive. We came from all over the country with different upbringings, and yet we were one." Manobianco also echoed the sentiments of many men when he said "I was no hero . . . but I was proud to have been a member of the armed forces."

Appendix A

A Bibliography of Italian Americans In World War II

Because so many Italian Americans served in the United States Armed Forces during World War II, most unit histories or memoirs contain references to Italian-American servicemen by name. Such works are not listed here unless they deal substantially with Italian Americans (for example, see *1000 Destroyed,* by Hall, which refers often to American ace Don Gentile). Some Italian Americans who became famous after the war were the subject of biographies or the authors of autobiographies. Such works, if they contain significant material pertaining to the veterans' wartime service, are included in this list. Likewise, some general histories are included if they contain important information about Italian-American servicemen or veterans. This is, of course, only a partial list.

Aquila, Richard. *Home Front Soldier: The Story of a GI and His Italian American Family During World War II*. Albany, New York: State University of New York Press, 1999. This book contains Richard Aquila's letters to his family during his stateside wartime service. It is an interesting book capturing the story of soldiers stationed in the Zone of the Interior.

Bosia, Remo. *The General And I*. New York: Phaedra, Inc., 1971. A quirky book detailing Bosia's brief World War II service and his run-ins with Army authority. An interesting point of view by a man who felt he was persecuted for his pre war affiliations.

Ciardi, John. *Saipan, The War Diary of John Ciardi*. Introduction by Edward M. Cifelli. Fayetteville: The University of Arkansas Press, 1988. This is the wartime diary of poet and author John Ciardi, who served as a B-29 gunner in the Pacific Theater.

Corvo, Max. *The O.S.S. in Italy, 1942–1945: A Personal Memoir*. New York: Praeger, 1990. This is the story of Corvo's service as an officer and agent in Italy.

Granai, Edwin, editor. *Letters from "Somewhere. . . ."* Burlington, VT: Barnes Bay Press, 2000. This is a series of World War II letters from Captain Cornelius "Kio" Granai, U.S. Army.

Grashio, Col. Samuel C., USAF (Ret.), and Bernard Norling. *Return to Freedom*. Tulsa, OK: MCN Press, 1982. Grashio, whose parents came to the U.S. from Calabria, was an Army Air Forces pilot who was on the Bataan Death March and was part of the only successful escape from a Japanese prisoner of war camp.

Iannarelli, Anthony M., USN, Ret. And John G. Iannarelli. *The Eighty Thieves: American POWs in World War II Japan*. San Diego, CA: Patriot Press, 1991. This is the story of Iannarelli's capture in December 1941, and his subsequent imprisonment in Japanese prison camps until September 1945.

Icardi, Aldo. *American Master Spy*. Pittsburgh, Pennsylvania: Stalwart Enterprises, Inc., 1954. This is the story of Icardi's service as an officer serving behind the lines in Italy, working with partisans. It is one of the earliest memoirs by an Italian American World War II veteran.

Imparato, Colonel Edward T., USAF, Ret. *Into Darkness: A Pilot's Journey Through Headhunter Territory*. Introduction by Robert Barr Smith, Col., USA (Ret.). Charlottesville, VA: Howell Press, Inc., 1995. This is the story of Imparato's search for a crashed bomber in uncharted territory in New Guinea.

Imparato, Colonel Edward T., USAF, Ret. *Rescue From Shangri-La*. Paducah, KY: Turner Publishing Co., 1997. This memoir documents Imparato's involvement in the spectacular rescue of servicemen from the wild New Guinea jungle in the summer of 1945.

Imparato, Colonel Edward T., USAF, Ret. *MacArthur: Melbourne to Tokyo*. Shippensburg, PA: White Mane Publishing Co., 1997. This memoir documents Imparato's selection to fly an important peace delegation mission to Tokyo at the war's end.

Imparato, Colonel Edward T., USAF, Ret. *374th Troop Carrier Group, 1942–1945*. Paducah, KY: Turner Publishing Co., 1998. Imparato was the Group commander for part of the war.

Lombardo, Samuel. *O'er the Land of the Brave*. Shippensburg, PA: Beidel Printing House, Inc., 2000. Lombardo, born in Calabria, came to the U.S. as a child and served as an infantry officer during the war. He and his unit made the first American flag to fly east of the Rhine River during the war.

Lovoi, Joseph W. *LISTEN. . . My Children—And Stay Free*. New York: Vantage Press, Inc., 2000. This is the story of Lovoi's internment in a German Prisoner of War camp.

Milano, James V., Col., USA (Ret.), and Patrick Brogan. *Soldiers, Spies, and the Rat Line: America's Undeclared War Against the Soviets*. Washington, D.C.: Brassey's, 1995. This work covers the author's experiences as an Army intelligence officer in World War II and the occupation.

Moramarco, Nick. *Missing in Action*. Santa Barbara, CA: Fithian Press, 1999. This is the story of Moramarco's internment in a German Prisoner of War camp.

Mustacchia, Nick. *Prisoner of War and Peace*. Raleigh, NC: Pentland Press, Inc., 1999. This is the story of Mustacchia's internment in a German Prisoner of War camp.

Norton, Maj. Bruce H., USMC (Ret.), and M.Gy. Sgt. Len Maffioli, USMC (Ret.). *Grown Gray in War: The Len Maffioli Story*. Annapolis, MD: Naval Institute Press, 1997. Maffioli was a combat veteran of World War II, Korea, and Vietnam. While this biography covers his entire life and service in all three wars, it concentrates upon his time as a P.O.W. of the Chinese Communists during the Korean War.

Picardo, Eddie. *Tales of a Tail Gunner: A Memoir of Seattle and World War II*. Seattle, WA: Hara Publishing, 1996. Picardo records his story as a tail gunner during the war.

Spagnuolo, Mark M., DDS. *Don S. Gentile: Soldier of God and Country*. East Lansing, MI: College Press, 1986. This is the story of one of America's leading air aces during the war.

GENERAL HISTORIES

Iorizzo, Luciano J., and Salvatore Mondello. *The Italian-Americans*. The Immigrant Heritage of America series, Cecyle S. Neidle, editor. New York: Twayne Publishers, Inc., 1971.

LaGumina, Salvatore, Frank J. Cavaioli, Salvatore Primeggia, and Joseph A. Varacalli, editors. *The Italian American Experience: An Encyclopedia*. New York: Garland Publishing, Inc., 2000. Several entries of this exhaustive work deal with the topic of Italian Americans in the U.S. military.

Mangione, Jerre, and Ben Morreale. *La Storia: Five Centuries of the Italian American Experience*. New York: HarperCollins Publishers, 1992.

Musmanno, Michael A. *The Story of the Italians in America*. Your Ancestor Series. Garden City, New York: Doubleday & Co., Inc., 1965. Musmanno also writes briefly about his own experiences as an officer in the U.S. Navy during World War II.

MISCELLANEOUS

(Most of these contain only minimal references to their subject's military service.)

Berra, Yogi, and Tom Horton. *Yogi: It Ain't Over. . . .* New York: McGraw-Hill Publishing Company, 1989. This autobiography contains a brief description of Berra's wartime service in the U.S. Navy, including an account of Berra at the Normandy assault landings on June 6, 1944.

Capra, Frank. *The Name Above the Title*. New York, The MacMillan Company, 1971. This autobiography contains a description of Capra's brief service in the U.S. Army during World War I and a more thorough examination of his time as head of the U.S. Army's Motion Picture Service during World War II.

Durso, Joseph. *DiMaggio: The Last American Knight*. Boston: Little, Brown, and Company, 1995. This biography briefly covers Joe DiMaggio's service in the Army Air Forces during the war.

Guarino, Larry, Col., USAF (Ret.). *A POW's Story: 2,801 Days in Hanoi*. New York: Ivy Books, 1990. This covers Guarino's horrifying experience as a senior ranking officer in Hanoi POW camps. Guarino was also a veteran of World War II, having flown combat missions in Italy and, ironically, the Hanoi area; he provides only brief mention of his previous war experience.

Hall, Grover C. Jr. *1000 Destroyed: The Life and Times of the 4th Fighter Group*. Fallbrook, CA: Aero Publishers, Inc., 1978. This unit history contains references to Don Gentile, a leading American ace during World War II.

Rizzuto, Phil, and Tom Horton. *The October Twelve: Five Years of New York Yankee Glory, 1949–1953*. New York: Forge, 1994. This history contains a brief account of Rizzuto's service in the U.S. Navy during World War II. Rizzuto is candid in his expression of the easy duty he and some other professional ballplayers had; many served in units that traveled to military outposts playing exhibition baseball games for the benefit of fellow soldiers.

Savelli, Ben A. *My Silent Partner*. San Francisco: Ben A. Savelli, Publisher, 1996. Savelli's parents and grandparents came to San Francisco from Calabria, in the early 20th century. A large portion of his memoirs is devoted to his experience as a soldier at various stateside bases during World War II.

Appendix B

Italian American Medal of Honor Winners, World War II

Some sources list 13 Italian-American Medal of Honor winners in World War II. However, there is some evidence to suggest that at least one more name should be added to that list: Second Lt. David R. Kingsley, whose maternal ancestors came from Italy (thanks to Fred Granata for providing information on Kingsley). Listed below are the 14 Italian American World War II Medal of Honor winners.

Sgt. John Basilone, Seventh Marines, First Marine Division, U.S. Marine Corps. Guadalcanal, October 24–25, 1942.

M/Sgt. Vito R. Bertoldo, Company A, 242nd Infantry Regiment, 42nd Infantry Division, U.S. Army. Hattan, France, January 9–10, 1945.

First Lt. Willibald C. Bianchi, 45th Infantry, Philippine Scouts, U.S. Army. Bataan Province, Philippine Islands, February 3, 1945.

Corp. Anthony Casamento, Company D, Fifth Marines, First Marine Division, U.S. Marine Corps. Guadalcanal, November 1, 1942.

Maj. Ralph Cheli, U.S. Army Air Corps. Wewak, New Guinea, August 18, 1943. (Air Mission.) Posthumous award.

PFC Joseph J. Cicchetti, Company A, 148th Infantry Regiment, 37th Infantry Division, U.S. Army. South Manila, Luzon, Philippine Islands, February 9, 1945. Posthumous award.

PFC Michael Colalillo, Company C, 398th Infantry Regiment, 100th Infantry Division, U.S. Army. Near Untergriesheim, Germany, April 7, 1945.

T/Sgt. Peter J. Dalessondro, Company E, 39th Infantry Regiment, Ninth Infantry Division, U.S. Army. Near Kalterherberg, Germany, December 22, 1944.

Corp. Anthony Peter Damato, U.S. Marine Corps. Engebi Island, Eniwetok Atoll, Marshall Islands, February 19–20, 1944. Posthumous award.

S/Sgt. Arthur F. DeFranzo, First Infantry Division, U.S. Army. Near Vaubadon, France, June 10, 1944. Posthumous award.

Second Lt. David R. Kingsley, 97th Bombardment Group, 15th Air Force, U.S. Army Air Corps. Ploesti Raid, Rumania, June 23, 1944. (Air Mission.) Posthumous award.

PFC Gino J. Merli, 18th Infantry Regiment, First Infantry Division, U.S. Army. Near Sars la Bruyere, Belgium, September 4–5, 1944.

PFC Frank J. Petrarca, Medical Detachment, 145th Infantry Regiment, 37th Infantry Division, U.S. Army. Horseshoe Hill, New Georgia, Solomon Islands, July 27, 1943. Posthumous award.

Second Lt. Robert M. Viale, Company K, 148th Infantry Regiment, 37th Infantry Division, U.S. Army. Manila, Luzon, Philippine Islands, February 5, 1945. Posthumous award.

Sources

Unpublished First Person Accounts

The author conducted numerous telephone interviews and exchanged e-mails and letters with the following World War II veterans:

Mike Altamura
Dave Azzari
Ralph Barrale
Dean Belmonte
Stephen Budassi
Pete Buongiorno
Johnny Campisi
Frank Carnaggio
Vince Carnaggio
Jim Caruso
Armand Castelli
Hal Cenedella
Lou Cerrone
Tony Cipriani
Vince Consiglio
Dom Constantino
Al Conti
Tootie DeBenedetto
Paul DeCicco
Bill Dirienzo
Bill Donofrio
Frank Fantino
Gill Fox
Vince Guzzardi
Ed Imparato
Mike Ingrisano
Tony Ingrisano

C.J. Lancellotti
Amiello Lauri
Tony Lima
Sam Lombardo
John Mangione
Dom Manobianco
Sam Mastrogiacomo
Tony Mastrogiacomo
Al Miletta
Mario Minervini
Pete Natale
Pete Palazzolo
Al Panebianco
Tony Pilutti
Art Pivirotto
Dom Porcaro
Albino Santelli
Charles Serio
Sam Speranza
Charlie Tortorello
Jim Vitton

The author received information on the following three men from their family members:
Joe Jacovino
Patrick Molinari
Warren Sorrentino

Bibliography

In addition to the works listed in Appendix A, the following works provided excellent background on Italian Americans, World War II, and the World War II GI.

Belmonte, Peter L. "Italian Americans in World War One and World War Two: An Overview." Paper presented at the 32nd Annual Conference of the American Italian Historical Association, 11–13 November 1999, San Francisco, California.

Commission for Social Justice, Grand Lodge of New York, Order Sons of Italy in America. *Italian-American Recipients of the Congressional Medal of Honor*. Undated pamphlet.

Gambino, Richard. *Blood of My Blood: The Dilemma of the Italian-Americans*. Garden City, NY: Doubleday & Company, Inc., 1974.

Howard, Gary. *America's Finest: U.S. Airborne Uniforms, Equipment and Insignia of World War Two (ETO)*. London: Greenhill Books, 1994.

Illinois Post (St. Louis Post-Dispatch). "Family from Herrin sent eight brothers to WW II," June 3, 1998. St. Louis, Missouri.

Kennett, Lee. *G.I. The American Soldier in World War II*. New York: Warner Books, Inc., 1987.

Rinker, Harry Jr., and Robert Heistand. *World War II Collectibles: The Collector's Guide to Selecting and Conserving Wartime Memorabilia*. Philadelphia: Courage Books, 1993.

Schoener, Allon. *The Italian Americans*. Commentary by A. Bartlett Giamatti, bibliography by Remigio U. Pane, epilogue by Lee Iacocca. New York: Macmillan Publishing Company, 1987.

Smith, Richard W. *Shoulder Sleeve Insignia of the U.S. Armed Forces, 1941–1945*. Erin, TN: Richard W. Smith, 1981.

Stanton, Shelby. *Order of Battle, U.S. Army, World War II*. Novato, CA: Presidio, 1984.

Sylvia, Stephen W.; and Michael J. O'Donnell. *Uniforms, Weapons, and Equipment of the World War II G.I.* Orange, VA: Moss Publications, 1982.

United States of America's Congressional Medal of Honor Recipients and Their Official Citations. Columbia Heights, MN: Highland House II, 1994.

VFW. "Past Commander-in-Chief Scerra Dies," December 1999. Kansas City, Missouri.